PLASTIC CAMERAS

To all the M's in my life

PLASTIC CAMERAS

Toying with Creativity

Michelle Bates

Amsterdam • Boston • Heidelberg • London
New York • Oxford • Paris • San Diego
San Francisco • Singapore • Sydney • Tokyo
Focal Press is an imprint of Elsevier

ELSEVIER

Focal Press

Acquisitions Editor: Diane Heppner
Project Manager: Paul Gottehrer
Assistant Editor: Stephanie Barrett
Marketing Manager: Christine Degon Veroulis
Cover Design: Alisa Andreola
Interior Design: Alisa Andreola
Typesetter: Charon Tec Ltd (A Macmillan Company), Chennai, India; www.charontec.com

Focal Press is an imprint of Elsevier
30 Corporate Drive, Suite 400, Burlington, MA 01803, USA
Linacre House, Jordan Hill, Oxford OX2 8DP, UK

∞ Recognizing the importance of preserving what has been written, Elsevier prints its books on acid-free paper whenever possible.

Library of Congress Cataloging-in-Publication Data
Application submitted

British Library Cataloguing-in-Publication Data
A catalogue record for this book is available from the British Library.

ISBN 13: 978-0-240-80840-6
ISBN 10: 0-240-80840-1

For information on all Focal Press publications
visit our website at www.books.elsevier.com

06 07 08 09 10 10 9 8 7 6 5 4 3 2 1

Printed in China

contents

acknowledgments

Many people have supported me throughout my photography career, in a variety of ways that have led to the creation of this book. I'd like to acknowledge them here.

At the beginning, my parents, Mimi & Harold Bates, Richie Lasansky, Jim Hogan, and the Maine Photographic Workshops helped me discover the joys of photography and of Holga.

Over the years since, many people have supported my photographic endeavors, including Ludmila Kudinova, Larry Busacca, Ike Royer, Llyle Morgan, Elizabeth Opalenik, Marita Holdaway, James Wood, Richard Newman, and Jennifer Loomis.

Recently, the following people have helped pave the way for this project to come into being. They include Jerry, Ike & Patrick at Freestyle Photographic Supply, Reid Callanan of the Santa Fe Workshops, and, especially, Diane Heppner of Focal Press, who proposed this project and kept me on track for two long years, and Paul Gottehrer, also of Focal Press, who corralled all the players into making the book so beautiful.

Several people assisted in the creation of this book. Leandra Darcy was assistant photographer wrangler. Randy Smith of HolgaMods, Cameratechs, Freestyle, and the folks at toycamera.com all supplied technical assistance. Mark Sink pointed me to many photographers, shared his archive and his endless enthusiasm. And Mary Ann Lynch most generously gave me photographers, history, advice, and her invaluable expertise in reviewing and editing the manuscript.

During the compilation of the images and writing of the manuscript, Tiberio Simone and Noah Iliinsky kept me fed and grounded, and Café Luna and Lighthouse Roasters gave me warm and friendly places to work. Vashon Island, as always, warmed my heart.

The contributors to this collection gave very generously of their images and their time, and wrestled with finicky computers to share them with me.

And, most of all, my dad, was, and is always, there with his 1000% support.

Helter Skelter, © Michelle Bates, 1991. This was an image I made with my first Holga, for which I created my unique negative carrier to encompass the whole image. Skowhegan State Fair, Maine.

introduction

This book is an introduction to the joys and frustrations of photographing with simple plastic cameras, and how these low-tech devices came to be so popular with photographers, both novice and experienced. Plastic cameras, such as the original Diana, its many clones, the Holga, and the dozens of other toy cameras available, appeal to a wide range of people. To some, they are a novelty; a cheap toy to play with. For others, they are a way to inexpensively get into medium-format photography. For many veteran photographers, they are a breath of fresh vision, allowing lightness and joy back into tired eyes.

I've been using Holgas since 1991, when I first studied photography at Maine Photographic Workshops and took one out to play. It was there that I created my vision through the plastic lens, aided by a cardboard negative carrier created to print the whole of a Holga image. Over these years, I've used Holgas to create and explore my personal vision, and to produce viable commercial imagery. I've also become involved in the community that has sprung up around these cameras locally, through exhibitions around the world, and, especially, on the internet. The fun these cameras stimulate in photographers has led me to teach workshops to demystify their use and energize users into taking a Holga (or Diana or Action Sampler) out to play. It is a delight to give photographers permission to immerse themselves in the joy of photography without the stress of having to have the latest and most complex, expensive equipment, or even to know anything about apertures and shutter speeds. At the same time, working with simple equipment provides a fun

way to slide into the technical skills that help photographers translate their artistic visions to printed reality.

Plastic Cameras: Toying with Creativity begins with a history of the cameras and how they came to be the popular tools they are today. In Chapter 2, and throughout the book, are images by the 33 contributing photographers, to whom I am grateful for their participation. The work represented here crosses the worlds of fine art, commercial, fashion and documentary photography, photojournalism, and portraiture. The photographers work in black-and-white and color; they tone, hand-color, digitally manipulate, and combine their images. They exhibit them, publish monographs, and use them for advertisements and in newsweeklies. In other words, photographers do the same things with a camera that costs about as much as a couple of movie tickets as they can do with any other camera.

Chapter 3 is a guide to some of the most popular plastic and toy cameras from the past and today. From there the book is a guide to photography with the Holga, with lots of information that can be used for shooting with other low-tech cameras as well. Finally, the Resources chapter provides you with a wide selection of websites, books, magazines, and galleries, where you can see more plastic camera images, get information, shop, and meet like-minded photographers.

Putting this book together has been a wonderful experience. I've spent countless hours tracking down photographers working with plastic cameras on the World Wide Web and in magazines and ordering every book I could find. I've had the chance to meet some photographers, talk to a few

more, and email all, catching them all over the globe. I've collected some new cameras, tried out different films, and taken apart several Holgas. There were the moments of giddy excitement during the process, like when I spread out the hundreds of thumbnail images of all the work contributed to the book and started to pick what would go where. What a joy to be in the presence of so much great photography and have the pleasure of putting it into print! Enjoy!

Mountain, © Nancy Rexroth, 1973, Route 50, Albany, Ohio, 4″-square silver-gelatin print. Courtesy

chapter one

What are Plastic Cameras?

Welcome to the low-tech, yet high-spirited, world of plastic cameras. Toying with

Creativity *is your guide through a camera experience far from the complexities of high-*

tech equipment. From the legendary Diana to today's favorite, the Holga, these lightweight,

simple to use, and cheap cameras conjure up an atmosphere of joy around image-making,

create intriguing photographs and make photographers and their subjects smile. Even better,

the images you make can proudly take their place alongside photographs made with the

most sophisticated cameras and lenses. Once you've mastered the art of shooting with a

plastic camera, the possibilities for what to shoot and where to use the images are endless.

While some might pick up a Holga or Diana for the first time and think, "This can't be a

real camera," or "How can this possibly produce good photographs?," images from these toys

are already being used in a wide range of commercial and non-commercial settings, from

gallery exhibitions to magazines and newspapers to advertising campaigns. With the boom-

ing popularity of easy-to-use digital cameras, some also may wonder why anyone would

want to tackle something that requires old-fashioned film, tape and chemicals; but for

those of us who've been magically drawn into the world of plastic cameras, there's often no

going back.

The ways plastic cameras have managed to infiltrate the world of photography over the past 40 years have surprised even their champions. Since their discovery by American photographers in the late 1960s, they've been used by teachers at varied levels to simplify teaching the basics of photography. New photographers are attracted to them for their affordability and high fun factor. For experienced photographers, these featherweights offer a break from more demanding cameras. Some even go on to adopt them into their arsenal of cameras. Even commercial photographers have taken the Holga or Diana on as part of their stash of equipment, often publishing plastic camera images without even a mention of their humble origins.

Plastic cameras are a surprisingly inexpensive way to get into photography. New cameras, like the Holga, are available for under $25, and while collectible classics like the Diana may go for three figures, many other styles can still be found for cheap. For photographers who've worked with 35 mm cameras, the Holga and Diana (and its clones) allow the step up to medium format photography, and its larger negatives, with a minimum of investment or worry. And for old pros, well versed in the most technical of equipment (think heavy), photographing with a Holga can be like flying, re-infusing photograph with the thrill lost over the years. While these cameras have little in the way of adjustments, usually don't need batteries, and are reusable (until they wear out), the negatives they produce can be traditionally printed in the darkroom, scanned for digital use, and reproduced in any context. What keeps people playing with these "plastic fantastics," even for decades, is the exuberance with which they relate to their low-tech companions, and the surprises that show up in the photographs.

So-called reverse technology also has the power to bring people together, almost the opposite of the often competitive world of photography. Communities have sprung up among plastic camera aficionados, resulting in a multitude of projects, from group exhibitions, web sites and forums, to World Toy Camera Day, involving photographers from throughout the world. "The Age of the Holga" has in fact been propelled by the rise of the internet, and, strange though it may seem for devotees of a low-tech toy, plastic fanatics have found one another using this newest in advanced technology: the World Wide Web. On-line bulletin boards and websites, such as the original toy-camera.org and the current toycamera.com, have become gathering places to view images and exchange information. The Lomographic Society has taken this community-building to its extreme, drawing together hordes of photographers in various countries via its website to take part in carefully crafted photo games, whose completion are celebrated with all-night revelry.

In the decades since the little blue Diana made its way into American photographic culture, around 1967, the complexity of these plastic cameras hasn't changed much. Although Holgas may be somewhat better quality than Dianas, their essentials are similar: both cameras are a (sort-of) light-tight box with a simple shutter, plastic lens, and few exposure adjustments. The selection of cheap toy cameras taking 35 mm, 120 or other size film, continues to expand, and toy digital cameras are a snazzy new addition to the market. As long as these cameras and the required film are available, no photographer ever need be without an image-making device. Meanwhile, at photography's high end, technology leaps ahead at an ever-quickening pace. In this climate of more money, more megapixels, and more complexity, all-manual plastic cameras provide a lifeline to photographic fun, a creative outlet for inspired artistic vision, and an antidote to the tyranny of technology.

WHERE DID THEY COME FROM?

Where did these toys-turned-serious photographic tools come from? Diana cameras first appeared in the US in the 1960s. They were manufactured by the Great Wall Plastics Company in Hong Kong, and sold for anywhere from sixty-nine cents to three dollars. With three apertures, one shutter speed (plus bulb), and three pictographic focus settings, the camera is simply a box for holding 120 film and letting in a little light. Originally stumbled upon in drugstores by curious photographers, Dianas were also discovered by educators at university photography programs, including Jerry Burchard at the San Francisco Art Institute and Arnold Gassan at Ohio University. By adopting the Diana in their beginning photography classes, they immediately leveled the field of equipment for their students. Using these simple cameras, students learned the same skills in composition and

creative vision that they would have learned with more expensive cameras, without the distraction of having to make complex camera adjustments. Because both their cameras and the film were cheap, the students were encouraged to shoot with abandon. Dianas in hand, students and faculty alike loosened up.

This early history is discussed by those who were part of it in "*$1 Toy Teaches Photography*" by Elizabeth Truxell of Ohio University in the January 1971 issue of *Popular Photography* and in several issues of *Shots* magazine during the 1990s (see Resources). Dianas had appeared on the scene at a time when photography was expanding its reach, just beginning to be accepted in the academic and fine art worlds. They fit right in with the cultural explosion of the times, in music and the arts, and the photographers who turned to the Diana came at camerawork from a broad range of perspectives and experiences. During the 1970s, Diana images began to be recognized in the art world, with Nancy Rexroth's photographs achieving quick recognition as important work. Her Diana series, *Iowa*, was exhibited at the Corcoran Museum in 1971, excerpted in Aperture's 1974 publication *The Snapshot* and published in 1977 by Violet Press as the first monograph of images done with a plastic camera (now a collector's item).

In 1979, The Friends of Photography in California put together *The Diana Show*, a juried exhibition that attracted over one hundred entrants. The catalog for this show, published in 1980, was the first collection of plastic camera photography, and featured an essay, "Pictures through a Plastic Lens", by David Featherstone, that is still the most well-known treatise on the subject. Regrettably, Diana cameras weren't around for very long; Featherstone mentions that they had already stopped being made before *The Diana Show* catalog was published. The Arrow, Banner, Dories, and several dozen other Diana clones continued to be made, usually in a shade of blue similar to the Diana, but in varying degrees of quality. The last of the line, the Lina, ceased to be made in the late 1980s, but

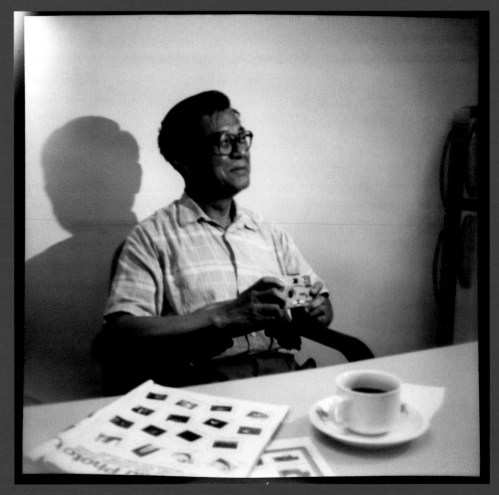

T. M. Lee, Inventor of the Holga, © Skorj. This portrait was taken with a Fujipet camera during a visit to the Universal Electronics factory by Tony Lim and Skorj in 2005, for an interview for *Lightleaks: A Magazine for Toy Camera Users,* Issue 2. My thanks to them and Mike Barnes for information used in this chapter.

for the photographer willing to troll yard sales or eBay, there are still many Dianas and her kin floating around.

For the more modern plastic camera photographer, we are currently in the Holga Dynasty. Holgas were invented by Mr. T.M. Lee, and introduced in 1982 by Universal Electronics, Ltd., from its factory in Kowloon, Hong Kong, the same area where Diana was born. The name Holga came from the Cantonese term hol-gon, which means "very bright" and was used as part of the company's logo. This was shifted a little, for easy English pronunciation, to Holga. The name WOCA, given to the glass-lensed version, came from the company's flash units.

Lee's idea for the Holga was to make available a cameras cheap enough to feed the market in China for 120 cameras, which at the time was huge. After a few years, 35 mm film caught on and the Chinese demand for the larger format fizzled. The Holga's saving grace was the United States market. In the early 1980s, Holgas were introduced at the Maine Photographic Workshops, where they took the place of the Diana and Dories cameras as low-tech educational tools for the workshops' students. Holga's availability at MPW and through their store made them accessible to photographers at large, and word spread quickly throughout the photographic community. As their popularity grew, imports increased, surprising even their manufacturers. By 1997, sales had increased to 10,000 a year in the US, and they currently sell over 100,000 per year worldwide. By 2004, more than 1,000,000 Holgas had been sold.

These days, Holgas are still an international hit. Even in the digital age, plastic cameras are keeping their foothold (a bargain at just one percent of the cost of my new digital camera). Selling around the world on websites and in camera and specialty stores, museum shops, and catalogs, they have escaped their predicted faddish demise every year since I bought my first Holga, in 1991. The line has since evolved and expanded, to include models with a bulb setting, tripod socket and color flash, but the basic unit is still the same shell of a camera.

In some ways, Holgas are even simpler than Dianas. The Holga has truly only one aperture (by some strange quirk, the aperture arm doesn't actually accomplish anything), and one shutter speed, with only the recent addition of a bulb setting. The focus ring has little figures to represent approximate distances, while Diana and her clones have actual distance numbers.

The Diana has one image format, which creates 4 cm × 4 cm images on 120 film. Holgas offer the options of two formats, either 6 cm × 6 cm squares, or 6 cm × 4.5 cm rectangles. In the larger square format, the sharper part of the image is in the center, while light and image quality fall off into the corners, creating the Holga's distinctive vignetted look. When Mr. Lee discovered this, he was disappointed, and ordered the counter switch to be glued to sixteen, forcing use of the smaller format. Luckily, he reconsidered, and with a simple adjustment, one can have a choice of the smaller rectangles or the vignetted squares, which Mr. Lee calls "four-corners-dark". The Diana-F line sports a dedicated detachable flash, while the Holga comes with either a built-in flash or a hot-shoe, for connecting any modern flash unit. The Holga 120SF was the first 120 camera with built-in flash, and its current versions may still be the only 120 cameras with this feature. More details on both cameras follow in Chapter 3.

Although the Diana developed a permanent cult following of its own, it took the combined popularity of the Diana, Holga, and other cheap "toy" cameras to spawn international movements revolving around the kaleidoscope of low-techs now on the market. The Lomographic Society (which even has Lomo boutiques) has played a huge part in this, creating an atmosphere of photographic giddiness around their flagship LC-A (glass-lensed) camera, as well as their newer creations of multi-lens toy cameras. In the States, Holga distributor Freestyle Photographic Supply has championed the Holga cause, offering a Holga enlarger and other accessories within the realm of affordable equipment. See Chapter 3 for a rundown of plastic cameras past and present.

Coming up next in *Toying with Creativity* is a selection of some of the best and most innovative work with Dianas and Holgas, from the very beginnings to the present. After that we'll get into the nitty-gritty of working with your Holga. First though, swing it around in the air and give a cheer for the joy of our simple but lovable toys!

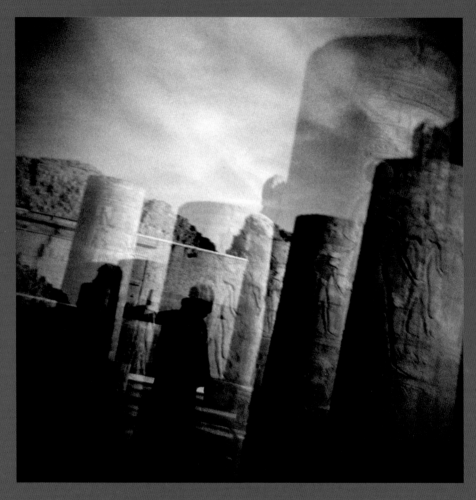

Kom Ombo, 2001, © Mary Ann Lynch, from *Entering Egypt*. Diana camera with Tri-X B&W 400 film. In-camera double exposure.

chapter two

Plastic Portfolios

Introduction

This chapter presents a unique collection of plastic camera images gathered from dedicated photographers far and wide specifically for this book. You'll see here some of the earliest images made with the Diana, in the late 1960s, as well as contemporary work showing a wide range of approaches and sensibilities. Some of the photographers in this section shoot exclusively with their plastic camera of choice, while some keep them as just one tool in their array of camera equipment. Some are champions of low-tech photography, while others publish their images without calling attention to their source. Images here have been used for fine art, advertising, to communicate the news and humanitarian crises, and to spread joy through the magic of photographic imagery. What all the photographers have in common is a natural talent for creating beautiful photographs, and a passion for their work. You can find more about all these photographers through links in the Resources section.

Nancy Rexroth—Plastic Pioneer

Nancy Rexroth was part of the beginning wave of plastic camera photography, although she wasn't aware of it at the time. As a graduate student at Ohio University, she discovered the Diana camera, which was being used as a teaching tool at the time. Soon she had fashioned the style of imagery that would earn her national acclaim barely out of school. Unlike the highly conceptual photography then in vogue, Rexroth's Diana images arose from what she calls "an almost obsessive love of the classic face of beauty." After her thesis show in 1971, she exhibited in a two-person show with her mentor, Emmet Gowin, at the Corcoran Gallery in Washington. D.C. This was a significant step for any photographer, and a unique honor for one using a one-dollar camera. From there, with a National Endowment for the Arts grant in hand, Rexroth moved back to Ohio and continued photography for *Iowa*, the Diana work she had begun in graduate school. Although in *Iowa* she was exploring the mental terrain of her childhood visits to rural Iowa, Rexroth did all the photography for the project in "lazy Appalachian towns in Southeastern Ohio."

Luminous, emotionally charged, and poetic, Rexroth's *Iowa* photographs were included in Aperture's publication *The Snapshot* in 1974. Three years later, *Iowa* (Violet Press, 1974) became the first published monograph of work done with a plastic camera. Rexroth was picked up by Light Gallery early on, and her work from *Iowa*, now highly collectible, continues to be widely shown. This seminal series revolutionized the relationship between toy cameras and the fine-art world. Rexroth has recently been using a thirty-dollar low-resolution digital camera, the Digipix, which makes square color images. In *The House* series, Rexroth again creates in an expressively personal vein, photographing in the Victorian house of a neighbor who has painted the interior in "fantastic, luminous colors."

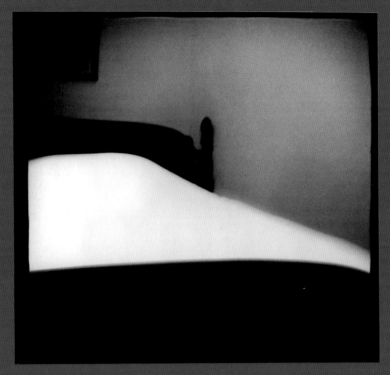

A Woman's Bed, © Nancy Rexroth, 1970, Logan, Ohio. The first Diana image that struck a chord with Rexroth; after this, images came "like a string of pearls" to create the *Iowa* series. 4″-square silver-gelatin print. Courtesy of Robert Mann Gallery.

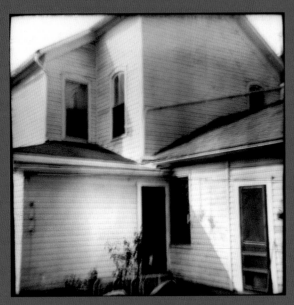

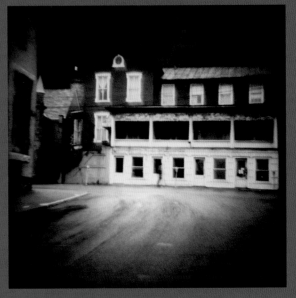

Folding House, © Nancy Rexroth, 1974, New Lexington, Ohio. From *Iowa*, 4"-square silver-gelatin print. Courtesy of Robert Mann Gallery.

Town, © Nancy Rexroth, 1971, Pomeroy, Ohio. 4"-square silver-gelatin print. Courtesy of Robert Mann Gallery.

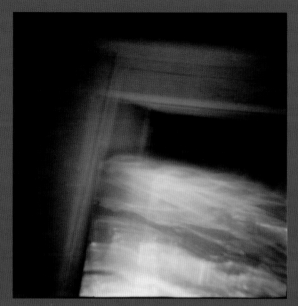

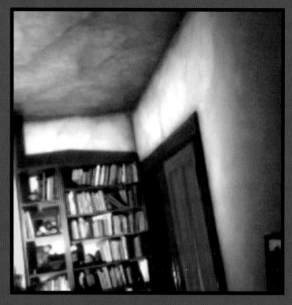

Streaming Window, © Nancy Rexroth, 1973, Washington, D.C. Diana camera 4″-square silver-gelatin print toned first with sulfide (sepia), then with gold. From *Iowa*, in Section III, which explores interiors. Courtesy of Robert Mann Gallery.

Library Ladder, © Nancy Rexroth, 2005. Digipix digital camera image made in Cincinnati, Ohio, from *The House Series*. 4″-square print.

Ted Orland—Parallel Careers

Ted Orland may well have been one of the first photographers to adopt the Holga, though he had not worked with the Diana. In the years when Diana was making waves, Orland was immersed in the opposite, super-sharp f/64 aesthetic while working with Ansel Adams as his student and assistant. While Orland appreciated the fuzzy vision that Nancy Rexroth and others were using, it took many years for him to disengage from the idea that "sharpness is good" and achieve the mental flexibility to appreciate the Holga's quirky qualities. Since discovering the Holga when it first debuted at Maine Photographic Workshops in 1990, Orland has used it as his primary camera. In his ongoing quest for creative ways to make images, he uses both color and black-and-white film, often hand-colors his prints, and makes montages in Adobe Photoshop®. Orland also uses a pinhole-modified Holga and occasionally takes a Holga for a swim sealed in a plastic baggie. He says, "what the Holga's capable of doing with a vengeance is capturing ambiance," which is made clear by the atmospheric mood of his images.

Orland, whose home base is Santa Cruz, California, enjoys parallel careers as both a teacher of digital photography and a writer; he recently published *The View from the Studio Door* (Image Continuum Press, 2006) and co-authored *Art and Fear* (Image Continuum Press, 1993). Orland is prolific in his creation of images, and generous in sharing his knowledge and insights with his students and readers alike.

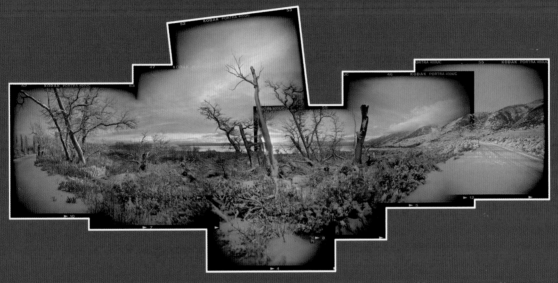

Winter Sunrise, Mono Lake, © Ted Orland, 2004. Holga camera with Kodak Portra UC 400 color-negative film. Scanned negatives are combined in Adobe Photoshop®.

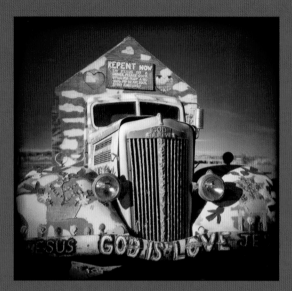

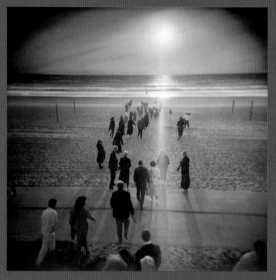

Born Again Truck, © Ted Orland, 2003. Holga camera with Kodak Portra Ultra color-negative film, scanned, and saturation increased in Adobe Photoshop®. The truck belongs to Leonard Knight, the creator of Salvation Mountain, a monumental folk-art piece in the desert near the Salton Sea, California.

Yuppies Marching into the Sea, © Ted Orland, 1991. Holga camera with T-Max 400 B&W film; silver-gelatin print hand-colored with oil paints.

David Burnett—Veteran Photojournalist

If anyone has taken advantage of all that photographic technology has to offer, it is David Burnett. In 40 years as a photojournalist, he has used every type of camera, from the simplest to the most current advanced digital. While Burnett appreciates what the highest of the high-tech can do, he also values the purity of the simple camera that forces you to really think about what you're doing.

After decades of documenting war, sports, and politics (including every president since John F. Kennedy), Burnett found shooting with the Holga to be a rekindling experience. It has allowed him to see as if picking up a camera for the first time, with nothing between his eye and his subject. A few years ago, Burnett realized that in the world of photojournalism, most shooters were using the same handful of 35 mm cameras and lenses, creating images that had uniformity in their look. To challenge himself, and create images that would cause a reader to pause, he began using his 55-year-old 4″ × 5″ Speed Graphic, a couple of 2 ¼″ × 2 ¼″ cameras, and the light and simple Holga.

From his home base in Washington, D.C., Burnett continues to travel the world, offering his new, but old-style, look to his news and sports photography with his various cameras, including the Holga. His photographic vision has been recognized many times over the years with awards, and recently two of his Holga images (including *Al Gore Campaigns*) garnered him White House News Photographers Association prizes.

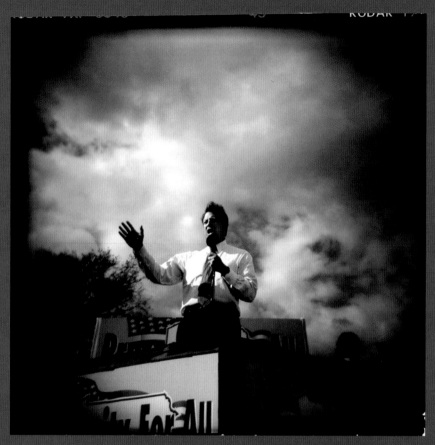

Al Gore Campaigns in Philadelphia Two Days Before the Election, 2000, © David Burnett/
Contact Press Images, 2000. Holga camera with red filter.

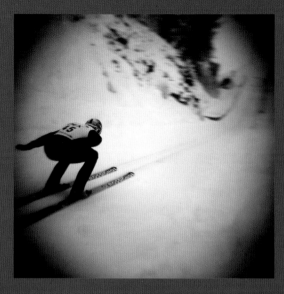

Ski Jump: Steamboat Springs, Colorado, © David Burnett/
Contact Press Images, 2005. Holga camera.

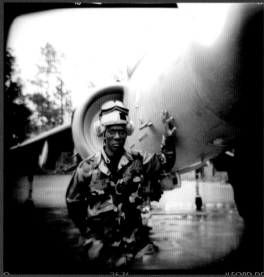

U.S. Marine Harrier Mechanic, Camp Lajeune, South Carolina,
© David Burnett/Contact Press Images, 2001. Holga camera.

Anne Arden McDonald

When people who don't know better see Anne Arden McDonald's images, with titles such as *Diana #24* or *Diana #35*, they sometimes think they're about the mythological goddess Diana, not the camera. McDonald doesn't mind, because Diana the Huntress is her favorite goddess. And it's easy to see the connection to ethereal realms and mythology in her photographs.

McDonald is well known internationally for a series of self portraits (made with a Nikon 35mm camera) in dilapidated spaces that have unique character. Her Diana work in the series *Pillow Book*, made with her collaborator Radek Grosman, are private performances created in places of a related abandoned feel. These series have taken her from her home in Brooklyn to several countries that have a much longer history, with buildings that reveal the character that comes with age.

McDonald describes her Diana series (the numbered images) as being about "vagueness and images half-remembered from the subconscious." She shoots with her Diana on the bulb setting, to add a dreaminess and unpredictability to her images. With her fresh artistic visions and ideas, McDonald makes a series of unfocused frames come together as a focused body of work.

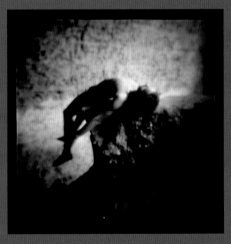

Fallen, Czech Republic, © Anne Arden McDonald, 1999. From the *Pillow Book* series, a collaboration with Radek Grosman. Diana camera on bulb setting.

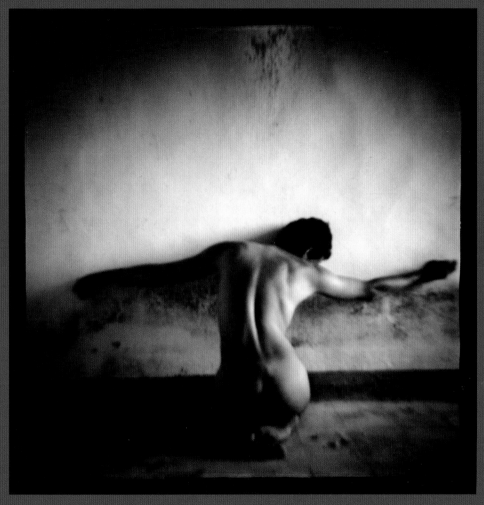

Hugging Wall, Italy, © Anne Arden McDonald 2000. From the *Pillow Book* series, a collaboration with Radek Grosman. Diana camera on bulb setting.

Diana #41, © Anne Arden McDonald, 1997.

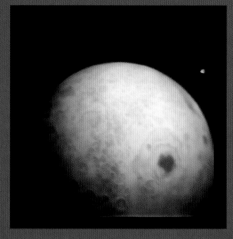

Diana #64, © Anne Arden McDonald, 1999.
Diana camera image of a model of the moon
in Italy.

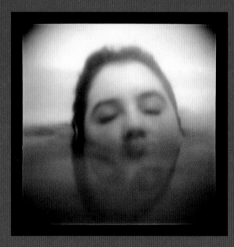

Diana #37, © Anne Arden McDonald, 1995.
Diana camera self-portrait.

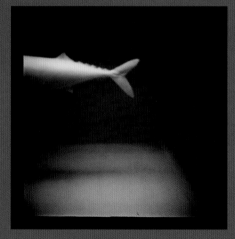

Diana #55, © Anne Arden McDonald, 2000.
Diana camera image from the Museum of
Natural History.

Nancy Burson—Compassionate Vision

Nancy Burson is one of the best known fine-art photographers who counts the Diana and Holga among her collection of photo tools. That she was also both an early pioneer in computer imaging and is a devotee of the huge and technically complex 20" × 24" Polaroid camera make her dedication to simple plastic tools all the more exceptional. Burson is well known for her ground-breaking technique of manipulating faces via computer to simulate the aging process. In her *Composites* series she merges images of several faces to create "averages." *The Human Race Machine* is an interactive exhibit that gives visitors the unique opportunity to see what they would look like as a different ethnicity.

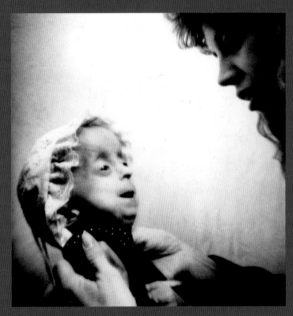

Untitled 1991, © Nancy Burson. Diana camera image from *Faces*.

Her Holga and Diana images are more straightforward. The subjects are calmly present, wrapped in the soft focus of the plastic lens. *Faces*, Burson's Diana series from the early 1990s, presents children living with genetic diseases, such as progeria, or injuries that affect the way they look, and hence interact with the world. Burson says it was her privilege to photograph these children, for "they are our teachers, as they are masters in the art of self acceptance." The *Faces* book was, for Burson, "about shifting people's vision, allowing the viewer time for their eyes to adjust."

For a more recent series, Burson took up the Holga, which she considers to be a step up from the Diana. Training her eye on healers, who use energy toward the treatment of disease, Burson relied on the Holga's single, uncoated plastic lens to record the frequencies they emit as part of the healing process. Several of these images are included in Burson's 2002 book, *Seeing and Believing*.

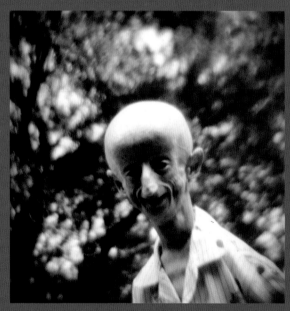

Untitled 1991, © Nancy Burson. Diana camera image from *Faces*.

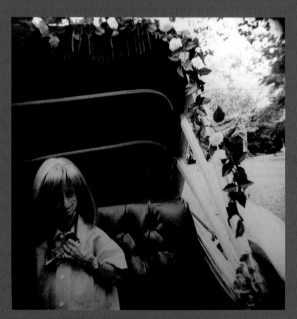

Untitled 1996–1997, © Nancy Burson. Holga camera, silver emulsion on anodized aluminum, 24″ × 24″, from *Seeing and Believing*.

From her New York studio, Nancy Burson continually creates new work by exploring and expanding her artistic vision. While the plastic cameras are only sometimes her tool of choice, in her hands, images made by a Diana or Holga are as powerful and moving as those made by any piece of equipment; they are an instrument for her to communicate her pioneering ideas to the world.

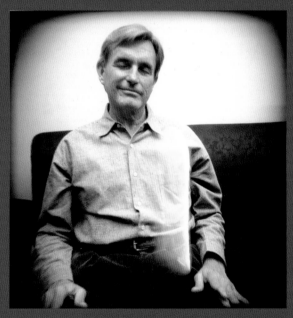

Gary (*Healing* Series), © Nancy Burson, 2000. Holga camera, chromogenic color print, 39″ × 39″.

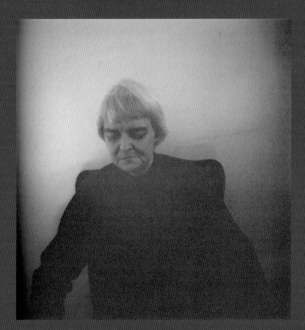

Nancy (*Healing* Series), © Nancy Burson, 2000. Holga camera chromogenic color print, 39″ × 39″.

Harvey Stein

Harvey Stein is a professional photographer, educator, lecturer, and author based in New York City. He teaches at the International Center of Photography and the New School University, and travels internationally lecturing on photography. Stein has shown his work in almost 200 solo and group shows, has several books of his images, and is represented in dozens of collections. His work has also been published in every photography magazine you can think of and in many other well-known periodicals.

With this kind of a resume, you might picture Stein with a Leica, and some of the time you'd be right. But it is just as easy to catch him wandering New York City capturing the continuous energy and clamor of its street life with a Holga.

Stein has several series done with the Holga. He aims to make "visually complex images that belie the simplicity with which they are made," as seen by this selection of street scenes. He manages to capture, with the most basic of instruments, the "rhythmic, spontaneous, ever-moving scenarios that constantly unfold, change, and disappear before (his) eyes."

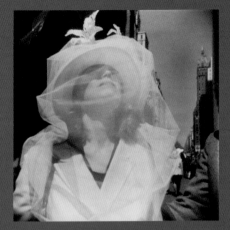

Easter Parade, New York City, © Harvey Stein, 1998. Holga camera split-toned 9″ × 9″ silver-gelatin print.

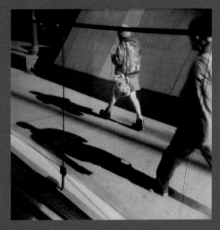

Two People, Two Shadows, © Harvey Stein, 2001. Holga camera split-toned 9″ × 9″ silver-gelatin print.

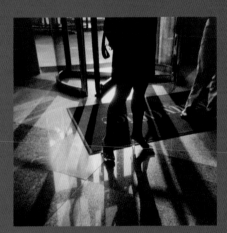

Legs, Austin, Texas, © Harvey Stein, 2002. Holga camera split-toned 9″ × 9″ silver-gelatin print.

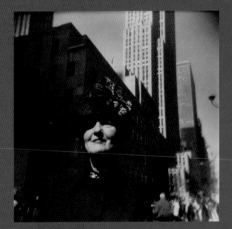

Woman on Fifth Avenue, © Harvey Stein, 2001. Holga camera split-toned 9″ × 9″ silver-gelatin print.

Pauline St. Denis

In the world of commercial photography, Pauline St. Denis may make the most sophisticated use of that most austere piece of equipment, the Holga. Over the past 25 years, St. Denis has perfected her system of doing multiple-exposure panoramas, using studio strobes and transparency film to create spectacular images for the music and fashion industries. Each of these techniques, materials and pieces of equipment presents its own difficulties in working with a plastic camera; together they create a photographic set-up that would boggle the minds of most Holga users.

St. Denis begins by loading the Holga with 200 ISO color transparency film (she also has used the now-unavailable Agfa Scala B&W). She connects strobe lights via a PC cord and adapter. Next she fine-tunes the exposure by adjusting the strobe output or adding neutral-density filters.

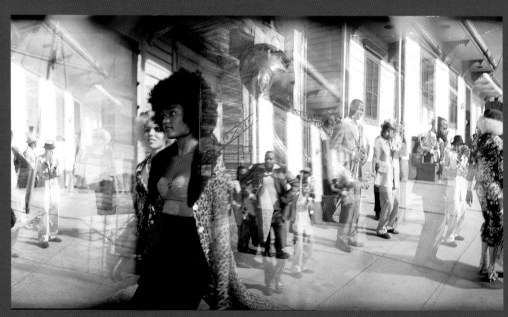

My N.O., L A, © Pauline St. Denis, 2000, for Dolce and Gabanna.

When shooting, St. Denis trusts her intuition, and doesn't look through the Holga's viewfinder. This allows her to hide the moment of exposure from some of her subjects. Knowing each of her Holgas personally, she chooses them for the particular look they produce; one tends to be sharper, while another creates more flare. The panoramic format is achieved by winding the film only partway, so that adjacent frames overlap and the resulting image is much longer than normal. While most photographers fight light leaks, St. Denis sometimes adds them deliberately by blasting light through the film counter window or along the edges of the film. Altogether, these techniques and St. Denis' methodical experimentation make for stunning, colorful compositions.

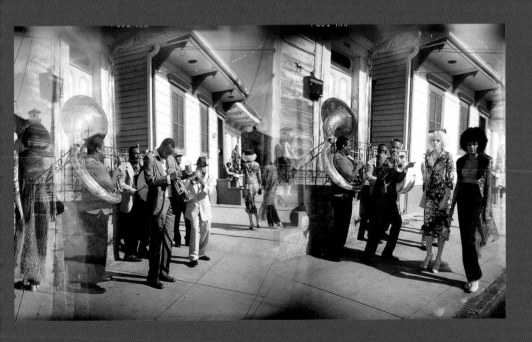

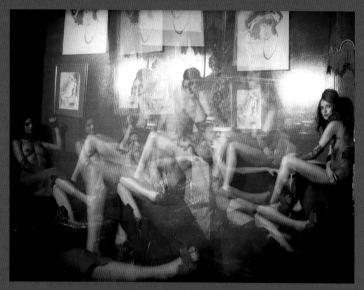

Moulin Rouge, © Pauline St. Denis, 2001, for *Contents Magazine*.

Big Blu Table, © Pauline St. Denis, 2003, for Kool.

Michael Ackerman—Poetic Visionary

Michael Ackerman is a unique photographer. Instead of going for the "decisive moment," he shoots the in-between moments. This slightly awkward timing leads to edgy photos, with a dramatic power and poetic vision. Ackerman uses his Holgas alongside several other camera formats, creating bodies of work held together by his particular vision and style. He has collected his images into two volumes. *End Time City*, is a series of photographs made in Benares, India. *Fiction* features images made all over the world, but doesn't identify its subjects. It also mixes images by many cameras, and includes three complete Holga contact sheets. Ackerman, who was born in Israel and grew up in New York City, now wanders across borders, photographing ceaselessly, trying to capture the emotions he experiences in a place. He is represented by Galerie Vu in Paris, where his work has achieved much recognition.

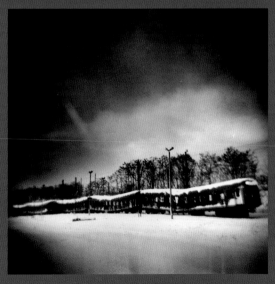

Katowice 2005, © Michael Ackerman.

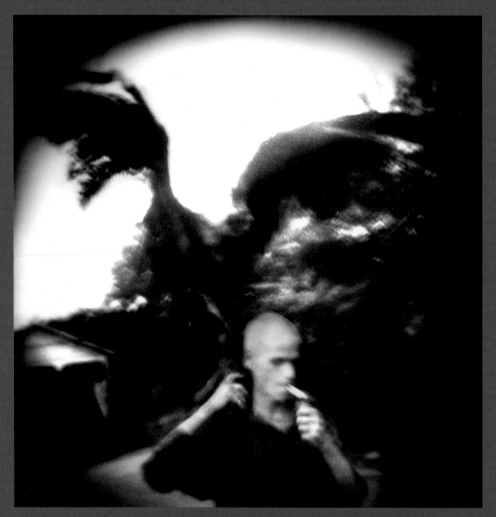

Atlanta, 1997, © Michael Ackerman.

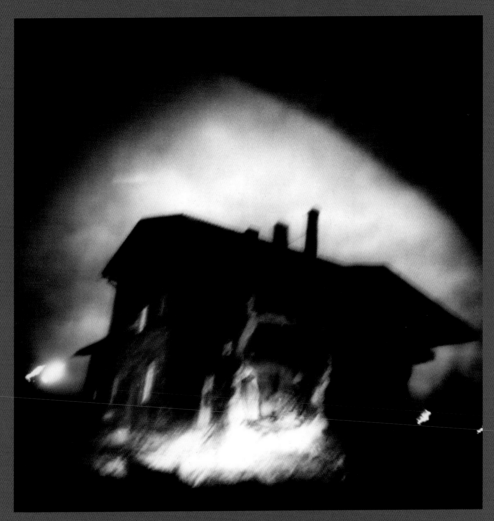

By Tom 1999, © Michael Ackerman. Published in *Fiction*.

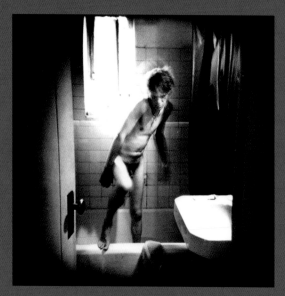

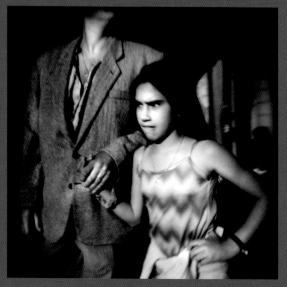

New York 1999, © Michael Ackerman. Image published as part of a contact sheet in *Fiction*.

Cannes 1999, © Michael Ackerman. Published in *Fiction*.

Mark Sink—the Diana King

Mark Sink and the Diana have had a long and fruitful relationship. It began in the late 1970s, when he discovered a Diana he had used as a child, with undeveloped photos of his mother still inside. Seeing these images taken from his short vantage point, he realized the art potential, thinking he was breaking new ground. After winning a Kodak Images in Silver Award with images from his first Diana, his bubble was burst when he learned that Dianas had made the rounds, and, in fact, The Diana Show had already been published. Luckily, he trudged on with his little blue love and continued to make art, having his first solo show in New York in 1986 with the Diana series *Twelve Nudes and a Gargoyle*.

Sink had Dianas in hand, right next to his trusty Polaroids, while living in New York City and hanging around Andy Warhol at the Factory throughout the 1980s. Starting with self-portraits shot with flash, and moving on to elaborate studio setups, Sink produced memorable photographs in the fine-art and commercial realms. He has captured the images of many celebrities, including Warhol, Jean Michel Basquiat, and Rene Ricard.

A relentless community organizer, Sink has coordinated various plastic camera projects over the years, in addition to opening Gallery Sink in Denver, co-founding the Denver Museum of Contemporary Art, and curating The Denver Salon. Sink teaches workshops and continues to pursue his own art and commercial work. He has written extensively about Dianas and other toys, and been a juror for the Krappy Kamera show at Soho Photo Gallery in New York City.

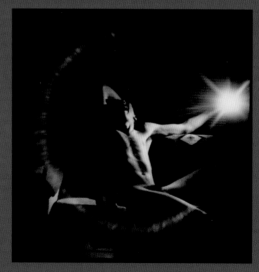

Self Portrait, © Mark Sink, 1979–1980. One of Sink's first Diana images, on Tri-X film.

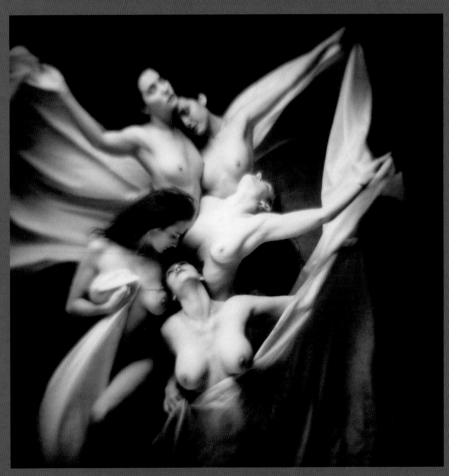

Nymphs #1, © Mark Sink, 1997. Plus-X film.

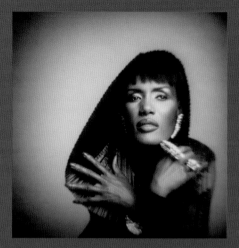

Grace Jones, © Mark Sink, 1989. Taken with studio strobe light on Plus-X film.

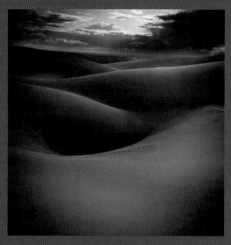

Dunes, Great Sand Dunes National Monument, Colorado, © Mark Sink, 1998.

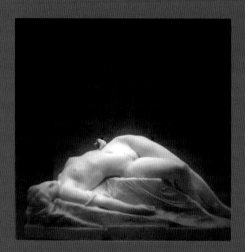

Nude 2 Canova Nude, © Mark Sink, 1987.

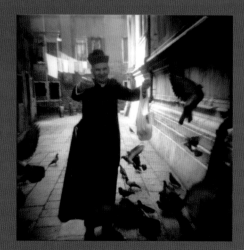

Italy Priest, © Mark Sink, 1998, Venice.

Perry Dilbeck

Commercial photographer and instructor at the Art Institute of Atlanta, Perry Dilbeck is another accomplished shooter who counts the Holga among his cameras of choice. Dilbeck has spent more than eight years on a series of images called *The Last Harvest: Truck Farmers in the Deep South*, documenting a fading way of life. Images from this series have been published in a number of magazines, and Dilbeck received a sponsorship from the Blue Earth Alliance for the project. The 2006 book of the series is available from University of Georgia Press.

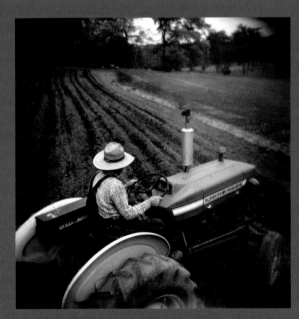

Spring Plowing, © Perry Dilbeck, 2004, from *The Last Harvest: Truck Farmers in the Deep South*. Holga camera image; 14″ × 14″ silver-gelatin print.

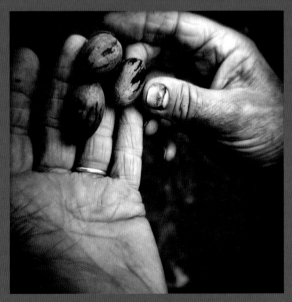

Pecans, © Perry Dilbeck, 1998, from *The Last Harvest: Truck Farmers in the Deep South*. Holga camera with old movie projector lens attached; 14″ × 14″ silver-gelatin print.

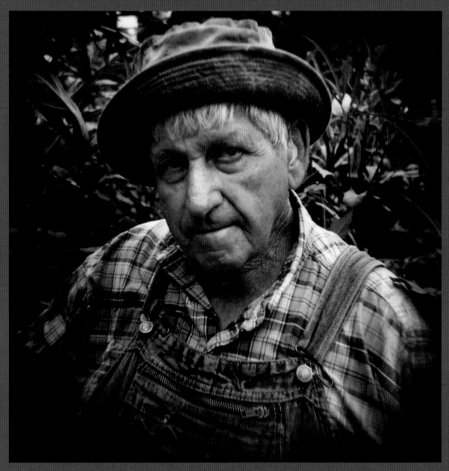

Leavell Smith, © Perry Dilbeck, 2003, from *The Last Harvest: Truck Farmers in the Deep South*. Holga camera image; 14″ × 14″ silver-gelatin print.

Jonathan Bailey

Jonathan Bailey has been making photographs for 30 years, but that's not all he's been doing. When not photographing with a Diana or large-format camera, he's been found lobstering (he does live in Maine, after all) or making wine. Within the world of photography, he exhibits, teaches, writes, and lectures extensively. Not content to leave his photographs alone, he has pulled them together in various forms such as books and collages, or integrated them into paintings. While he has mastered many complex techniques, Bailey now says that he has "come to prefer the use of tools and processes over which I can exert only limited control. This allows the medium itself a greater voice in the process." Bailey shoots with Diana cameras on Tri-X film and split-tones all his images.

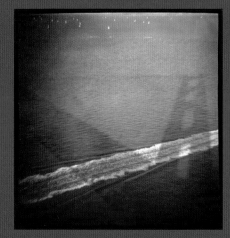

Puerto Escondido, © Jonathan Bailey, 1991, Oaxaca. Sepia-toned Diana camera print.

Golden Gate Bridge, © Jonathan Bailey, 2002. Gold-toned Diana camera print.

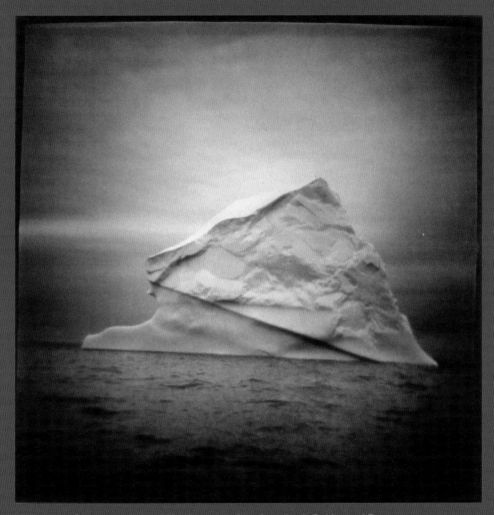

Iceberg #13, © Jonathan Bailey, 2004, Bonavista, Newfoundland. Gold-toned Diana camera print.

Susan Bowen—Plastic Panoramas

Susan Bowens's panoramic images, made by overlapping several frames on her Holga camera, capture the vitality and intense pace of life in New York City (her home city) and Las Vegas. Given that she has a day job as a computer programmer, her exhibition history is amazingly long, as are her

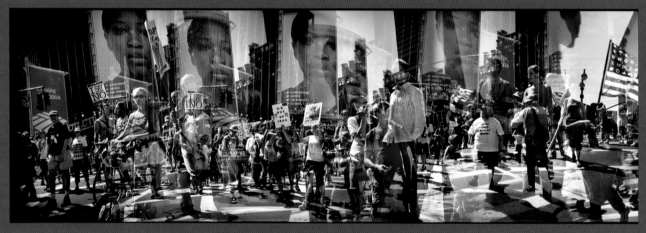

Does Bush Really Know (and Flag), © Susan Bowen, 2006. Anti-Bush/Anti-war protest, Republican National Convention in New York City. Holga camera with Kodak Portra 800 color-negative film.

mural-sized prints, which can extend up to eight feet! Bowen's images take advantage of the Holga's wonderful ability to capture color, and her eye pulls an ordered beauty out of the chaos of the scenes she shoots. She says, "It delights me how well these mostly unplanned juxtapositions capture my experience of a particular time and place and at the same time have an identity all their own."

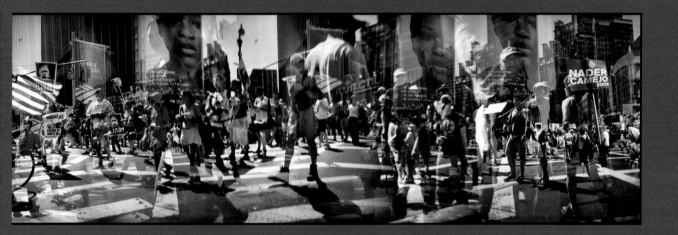

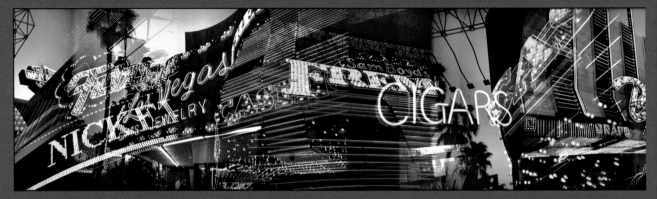

Lights of Fremont, Golden Nugget, © Susan Bowen, 2005, Las Vegas. Holga camera with Kodak Portra 800 color-negative film.

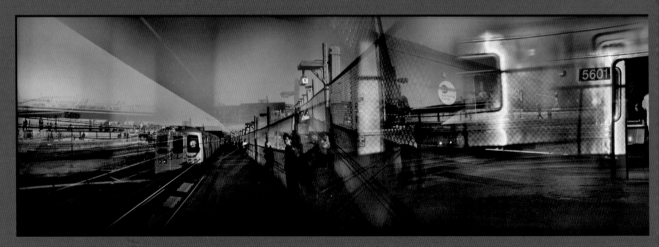

Departing G at Dusk, © Susan Bowen, 2003, New York. Holga camera with Kodak Portra 800 color-negative film.

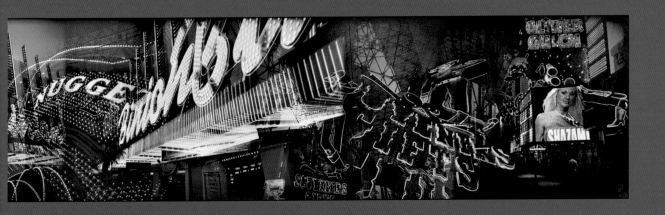

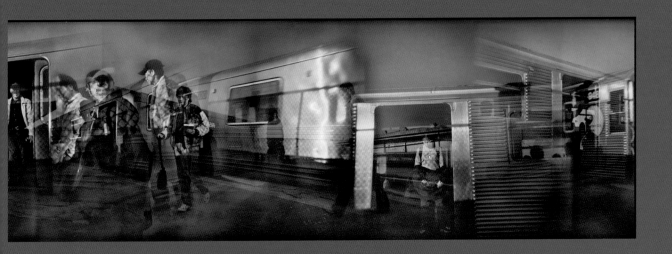

Mary Ann Lynch—Creative Catalyst

Mary Ann Lynch relies on her many muses, both to create her art and to develop new venues for artists. Throughout her long, inspiring career as photographer, writer, filmmaker, and educator, Lynch has melded together words and images to much acclaim. Simultaneously, she has founded organizations, competitions, and publications in photography and the arts from New York to Hawaii.

Lynch's journey with the Diana began in 1972, when she was living in Hawaii and using 35 mm and medium-format equipment. Her first Diana, from a little photography shop in Chinatown, led the way for dozens more as the humble instrument became a necessary part of her creative life. It would eventually become her primary camera for photographing energetic fields and places of power, "where one feels more than the eye can see."

Lynch's plastic camera projects, done with Dianas and several clones, encompass a wide range. *Sweet Inspiration* lets the viewer travel to places that have nurtured creativity, from Yaddo, the artists retreat, to Elvis' birthplace. For *Entering Egypt*, Lynch found that only her Diana images "held the heightened sense of reality transformed" that she felt in the ancient temples and landscape. *The Adirondacks* captures the area's historic locales with long exposures used to create dreamy colors that evoke the past.

Lynch co-founded, with Sandra Carrion, Soho Photo's National Krappy Kamera Competition, and is working on (yes, still), *Photography Through a Plastic Lens: Diana and Her Siblings*, an anthology of plastic camera photographs and photographers, 1968 to the present. Her writings about photography and popular culture appear in a variety of publications including *Camera Arts*, where she is Senior Editor. She divides her time between New York City and Greenfield Center in the Adirondack foothills.

Yaddo, 1992, © Mary Ann Lynch, from *Sweet Inspiration*. Diana camera with Tri-X 400 B&W film.

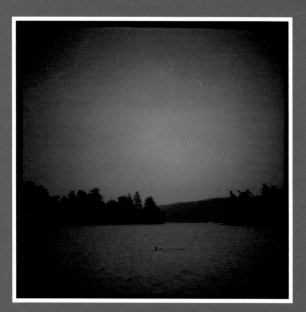

Magic Hour, Silver Bay, 1999, © Mary Ann Lynch, from *The Adirondacks*. Diana camera with Fujicolor NPH 400 negative film.

Silver Bay, 1999, © Mary Ann Lynch, from *The Adirondacks*. Diana camera with Fujicolor NPH 400 negative film. These long exposures were made with long bulb exposures, or multiple clicks of the shutter, some with time in between exposures to alter the image via a sort of time-travel. Lynch doesn't use a tripod.

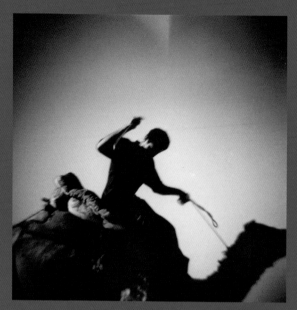

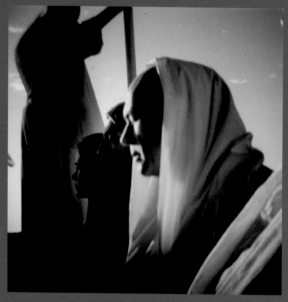

Nubia, 2002, © Mary Ann Lynch, from *Entering Egypt.*
Rover Camera (Diana variant) with Tri-X B&W 400 film.

Dawn Sail to Philae, 2000, © Mary Ann Lynch, from *Entering Egypt.* Diana-F camera with Tri-X B&W 400 film.

James Balog—Naturalist Photographer

James Balog expands the bounds of how nature is represented in photography. Of his 25-year career, he says, "I consider myself a photographic artist who looks for fresh ways for humans to look at nature and to understand themselves in relationship to it." In his world-famous series of images of endangered species, Balog brought them out of the idealized backgrounds they are usually pictured in, and framed them instead on stark white backdrops, creating stylized images that highlight their endangered status. For his latest series, Balog took on documenting the oldest and most spectacular trees in North America. To capture the massive might of the Stagg tree (the sixth-largest tree in the world by volume), he combined hundreds of digital photos taken from a neighboring tree, a task that involved hundreds of hours of post-processing. But to visually embrace a much smaller gnarled bristlecone pine, over 4000 years old, he pulled out a Holga. For *Audubon* magazine, Balog used his Holgas to document orangutans in Borneo. There, he created a compassionate portrait of these apes within their threatened environment, the Tanjung Puting National Park. Colorado-based Balog has also toted Holgas to Nepal, Africa and the Arctic.

Texas Live Oak, © James Balog, 1998, Leakey, Texas.

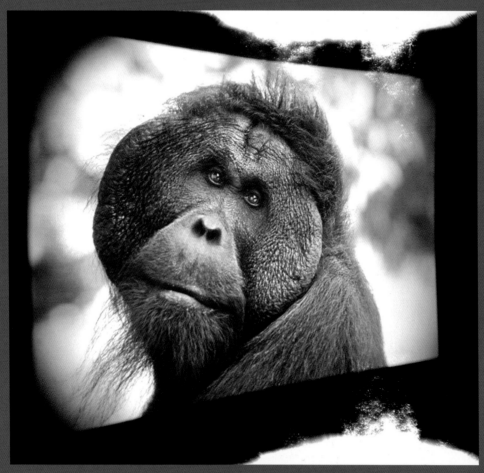

Borneo Orangutan "Kusasi," © James Balog, 1999, alpha male, Tanjung Puting National Park, Indonesia.

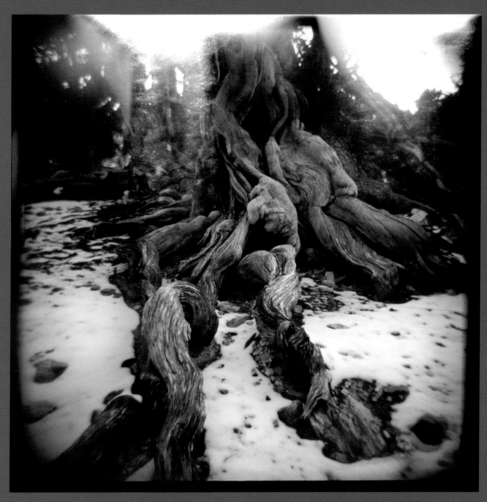

Intermountain Bristlecone Pine, © James Balog, 1998, Inyo National Forest, California. This is one of the oldest trees in the world.

Eric Havelock-Bailie

Eric Havelock-Bailie is an active member of the Denver photography community. He used nothing but Diana cameras from 1981–1993, and created a close-focusing portrait Diana by extending the lens barrel. His image making is, like his friend Wesley Kennedy's, very concept-oriented. These portraits were made just days before Kennedy passed away.

Wes Kennedy Number 2, © Eric Havelock-Bailie, 1993. Diana camera, modified for close focus, 15″ × 15″ silver-gelatin print.

Wes Kennedy Number 5, © Eric Havelock-Bailie, 1993. Diana camera, modified for close focus, 15″ × 15″ silver-gelatin print.

Wesley Kennedy—Photographic Light

Wesley Kennedy was a shining star of the Denver photography scene in the 1980s and early 1990s, until his death in 1993. He was an energetic explorer creating staged work with complex concepts, and capturing the images with a Diana camera. His personal and unique voice was an inspiration to

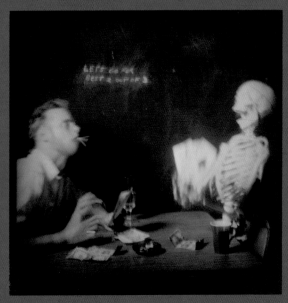

Cheating Death, © Wesley Kennedy, 1986, from *The Overman Series*. Diana camera image. Courtesy of Michael Murray.

photographers in his community. In a catalog accompanying a retrospective of Kennedy's work in 1993, critic Jane Fudge comments on *The Overman Series*: "This powerful group of photographs confronts primal fears and social problems at the same time. Kennedy sets the modernity of his sentiments about the unthinkable future against nostalgia for a misunderstood past."

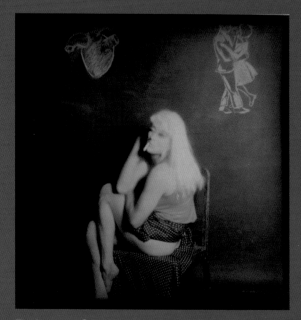

The Prostitute, © Wesley Kennedy, 1986, from *The Overman Series*. Diana camera image. Courtesy of Michael Murray.

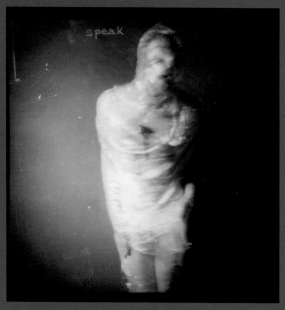

Speak, © Wesley Kennedy, 1986, from *The Overman Series*. Diana camera image. Courtesy of Michael Murray.

Franco Salmoiraghi—Changing Worlds

Franco Salmoiraghi was one of the earliest users of the Diana, arriving at Ohio University's graduate school in 1966. His thesis work there eventually became a series of pinhole images, but the Diana was, he says, "one of the 'doors of perception' to break down the walls of that training that demanded a specific set of aesthetics, point of view, and belief in the truth of the photographic image." He has used the Diana and dozens of other toy cameras over the years, as photographic series have called for it, or when it seemed time to bring out the simple camera.

Salmoiraghi's earliest Diana images, shown here, were made in 1967. When his first Diana's shutter broke after only a few rolls, he created a pinhole for it. With this modified Diana, he would subsequently make many evocative photographs.

Salmoiraghi has lived in Hawaii since the late 1960s, and while his plastic cameras work often involves poetic natural subjects and impressionistic portraits, it may equally explore darker subject matter. Another series, *Dementia & Transience*, consists of images taken while the photographer cared for his aging mother. Salmoiraghi found that the fuzzy Diana photographs mirrored the sense of timelessness and altered space perception that distanced her from her previous reality. Salmoiraghi describes *Regarding Death*, another somber, though uplifting, series, as "an investigation of the visual manifestations of the death experience in society."

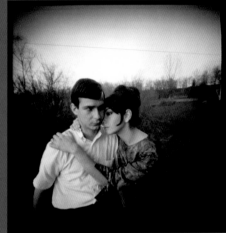

Bob & Sona, © Franco Salmoiraghi, 1967, Athens, Ohio. Pinhole-modified Diana, toned silver-gelatin print.

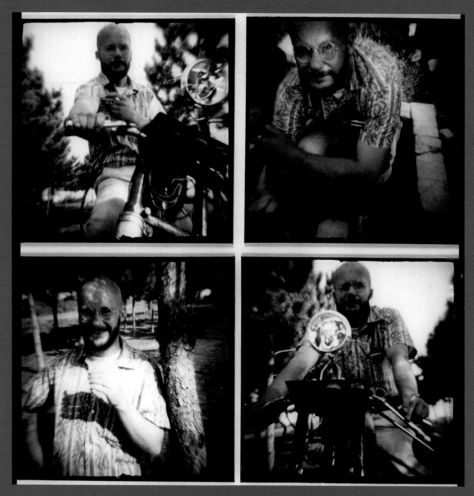

Motorcycle Guy, © Franco Salmoiraghi, 1967, Athens, Ohio. Diana camera (from one of his first Diana rolls; see the contact sheet on page 194).

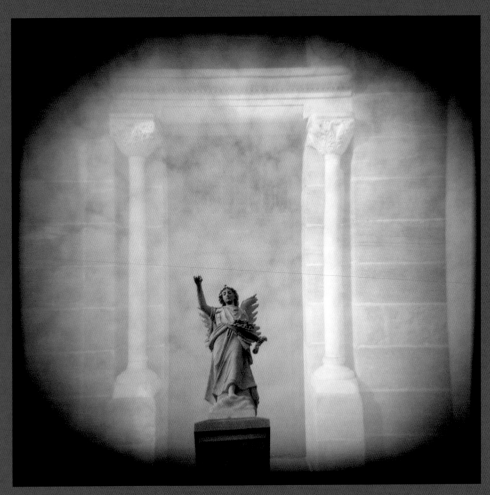

Guardian Angel, © Franco Salmoiraghi, 1998, Greenmount, Baltimore, Maryland. From *Regarding Death* portfolio. Holga camera double exposure, toned silver-gelatin print.

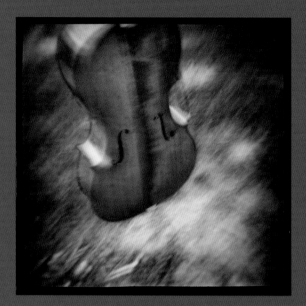

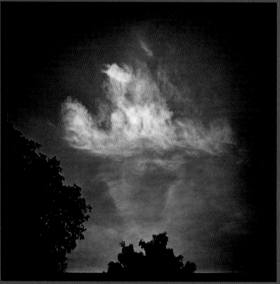

Swinging Cello, © Franco Salmoiraghi, 2002, St. Paul, Minnesota. Diana camera toned silver-gelatin print. From *Dementia & Transience: A Meditation on Aging and Memory Loss*.

High Mysterious Cloud, © Franco Salmoiraghi, 2002, St. Paul, Minnesota. Diana camera toned silver-gelatin print. From *Dementia & Transience: A Meditation on Aging and Memory Loss*.

Richard Ross

Richard Ross has an extensive 30-year catalog of exhibitions and publications to his name. A teacher at the University of California, Santa Barbara since 1977, he also does commercial photography, and creates highly conceptualized and designed exhibitions. The *Fovea* series consists of collections of dozens of images made with his Diana camera, from 1979 to the present, taken using the bulb setting. The collections are presented with the 30″ × 30″ images stacked edge to edge, floor to ceiling, allowing the viewer to swim in a sea of slightly blurry color images.

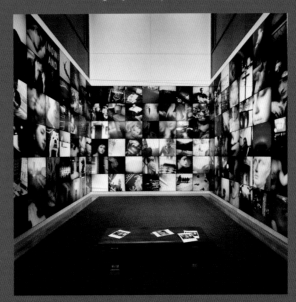

Fovea, © Richard Ross. 180″ high × 210″ across each of three walls. Opened September 11, 2001 at the Speed Museum of Art, Louisville, Kentucky.

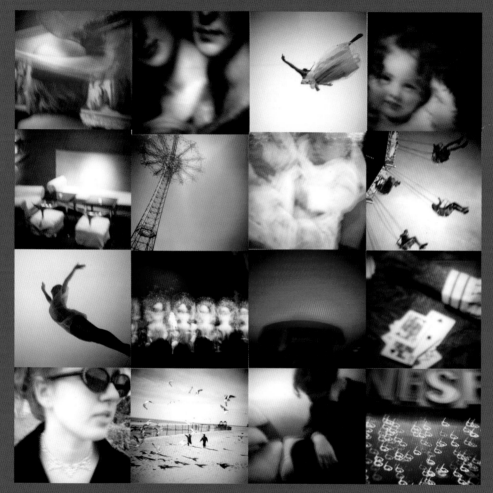

Fovea, © Richard Ross, 2006.

Teru Kuwayama—Humanitarian Photographer

Teru Kuwayama totes his Holgas as part of his collection of cameras all around the world documenting humanitarian crises. Working independently, he has witnessed wars and disasters in Iraq, Afghanistan, Pakistan, and New Orleans, and elsewhere. His dramatic, award-winning photographs have wound up in the pages of publications including *Time* and *Newsweek*. Not content with just seeing his work published, Kuwayama volunteers for Central Asia Institute, which builds schools in remote areas of Afghanistan and Pakistan. He dreams of having a "ruggedized" Holga that can withstand the rigors of his constant world travel. When he takes a break, he makes his home in New York City, where he helps run the Lightstalkers website, which provides an online home for those who wander the world for work and art.

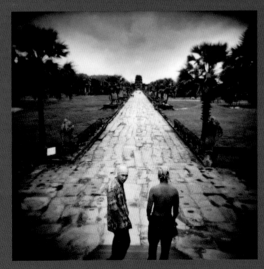

Cambodian Gang Members at Angkor Wat © Teru Kuwayama, 2003. They were deported from the United States for gang-related crimes.

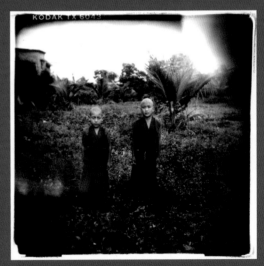

Tibetan Monks © Teru Kuwayama, 1998. Members of the Tibetan exile commuity, in Bylakuppe, India.

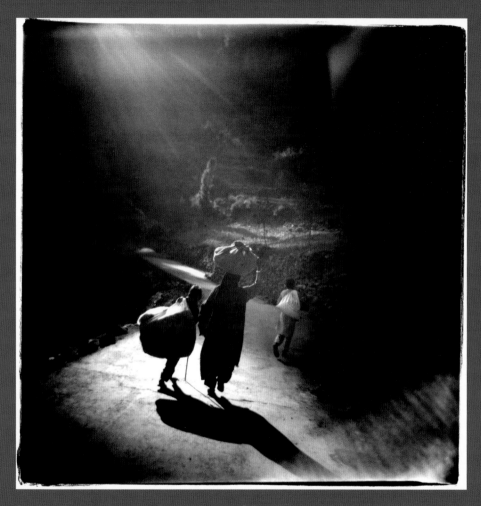

Relief Supplies, Nosari, Pakistan-Occupied Kashmir, © Teru Kuwayama, November, 2005. Holga camera on Tri-X film. A family carries away relief supplies from a distribution point in the mountains after the earthquake.

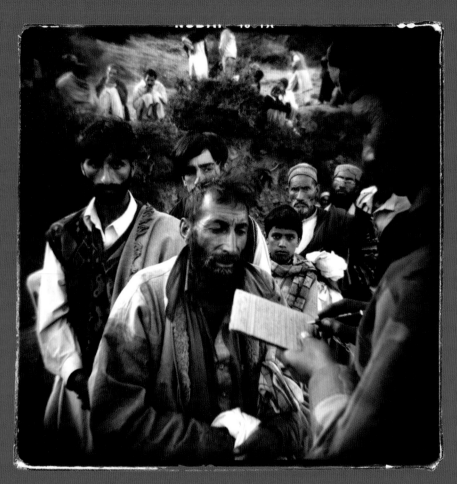

Relief Supplies, Nosari, Pakistan-Occupied Kashmir, © Teru Kuwayama, November, 2005. Holga camera on Tri-X film. Pakistan Army soldiers check ration cards as survivors line up for relief supplies. A massive earthquake killed some 80,000 people and displaced millions in the region.

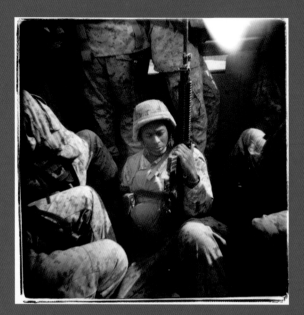

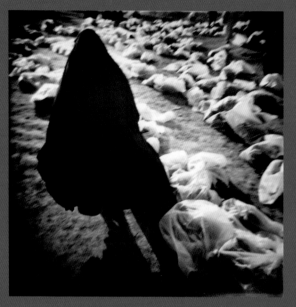

U.S. Marines in Khost, Afghanistan, © Teru Kuwayama, 2004. Holga camera on Tri-X film.

Exhumed Bodies at Mass Grave in Hilla, Iraq, © Teru Kuwayama, 2003. Holga camera on Tri-X film. A Shia woman, dressed in abaya, searches for family among recently exhumed bodies, believed to be those of Shias executed by the Saddam regime. The bodies, in plastic bags, are at a mass grave site at Hilla, near Baghdad.

Robert Owen—Shots Shooter

Robert Owen is a former editor (between Dan Price and Russell Joslin) of *Shots* Magazine. During his tenure at *Shots*, he published many plastic camera photographs, along with interviews with a number of Diana and Holga users, including Mark Sink, Nancy Rexroth, and Anne Arden McDonald. He put together Toy Camera Work II, and published a series of letters from early users of the Diana on how it came to be used as a teaching and fine-art tool, providing wonderful insight into the history of these special cameras (see Resources). An active photographer in his own right, Owen shoots with Diana and Arrow cameras, finding many delightful subjects in his hometown in Minnesota.

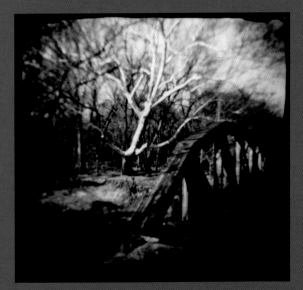

White Tree, Bridge, © Robert Owen, 1991. Diana camera images; gold-toned gelatin silver print.

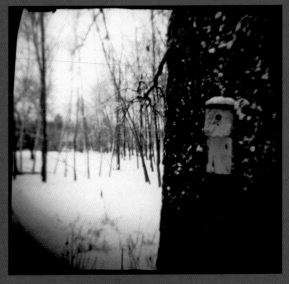

Birdhouse, Snow, © Robert Owen, 2001. Gold-toned, silver-gelatin print.

Cruise Ship Cooling, © Robert Owen, 1998.

Annette Fournet—Plastic Perception

Annette Fournet appreciates the beauty of things imperfect, impermanent, and incomplete. This description could refer to a Diana camera, but to Fournet, it describes the Japanese aesthetic of wabi-sabi that she brings to her images. Among other ideas, Wabi-sabi is based on tenets of intrinsic simplicity, intuition rather than logic, acceptance of the inevitable, and the beauty of the inconspicuous or overlooked detail. In such series as *Sticks, Stones & Bones*, Fournet photographs the changing landscapes of central Europe and the American south, both places with a strong cultural heritage that is giving way to the inevitable forces of change.

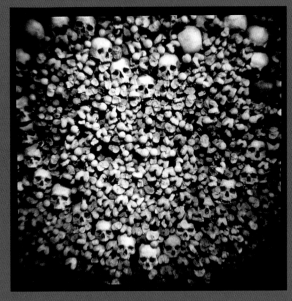

Melnik, Czech Republic, © Annette Fournet, 1999, from the *Sticks, Stones, & Bones* series. Diana camera with bulb setting; image made in an ossuary of sculptures made of plague victim bones.

As a long-time photographer and educator, Fournet has been able to create images of lasting beauty with her Diana, which she first discovered in the late 1980s, and which she continues to treasure for its unique qualities. Documenting places such as the Czech Republic, where she founded and spent eight years running the

Prague Summer Program, Fournet has captured scenes from lonely scarecrows in disappearing villages to a sad longing in ossuaries. Wabi-sabi may be how Fournet describes her images, but the idea also describes the simplicity, inevitable flaws and unknowing angst of photographing with our beloved plastic toys.

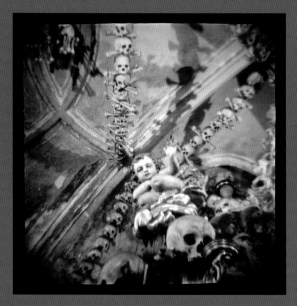

Sedlec, Czech Republic, © Annette Fournet, 2005, from the *Sticks, Stones, & Bones* series. Rand camera (Diana clone), taken in an ossuary.

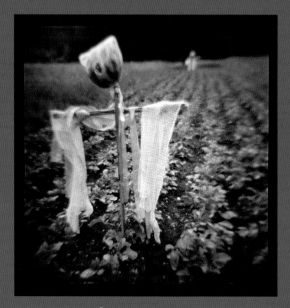

Kalimbina, Poland, © Annette Fournet, 2004, from the *Sticks, Stones, & Bones* series. Diana camera image made amidst the confused stares and questions of the Polish locals.

Sandy Sorlien—Armchair Antarctica

She may not have made it to Antarctica (yet), but Sandy Sorlien has been to more places in the United States than most of us will ever see. Her book, *Fifty Houses*, shows one representative house from each state, while *Main Streets* takes us on a photographic journey to quaint little towns scattered in the big empty spaces on the map. For *Imagining Antarctica*, Sorlien decided that since she couldn't get to the remote continent in person, she would create images that represented what she thought it would look like. The resulting series of photographs, taken during an unusually harsh winter in the Northeast, look very much like they could be from Antarctica, or the moon, for that matter. Using a Holga camera to accentuate the fantasy, Sorlien takes us on a tour of her imagination, with dramatic images and humorous flair.

Sorlien teaches photography at the University of Pennsylvania in Philadelphia, but doesn't limit her artistic outlets to film; she is currently creating an art car with a 1964 Volvo and tens of thousands of marbles. Sorlien also writes about photography and her travels, is an active member of the Society for Photographic Education and is involved in the rebuilding of Mississippi Gulf Coast towns that were ravaged by Hurricane Katrina.

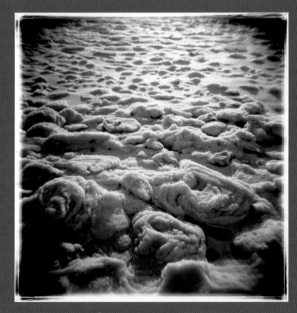

Snow, New Jersey, © Sandy Sorlien, 1996, from *Imagining Antarctica.* Holga camera, silver-gelatin print, 18″ × 18″.

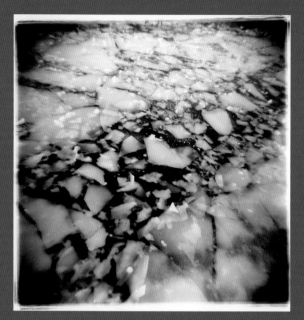

Ice, Philadelphia, © Sandy Sorlien, 1996, from *Imagining Antarctica.* Holga camera, silver-gelatin print, 18″ × 18″.

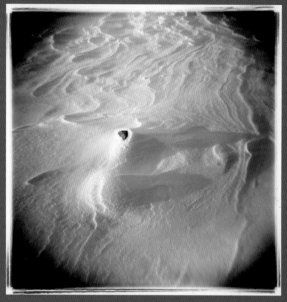

Snow, New York, © Sandy Sorlien, 1996, from *Imagining Antarctica.* Holga camera, silver-gelatin print, 18″ × 18″.

Michelle Bates

I've been playing with Holgas since 1991. I started out photographing fairs and yard kitsch, subjects that suit the Holga and my quirky vision quite well. Over the years I've used Holgas to photograph for weekly newspapers, and to document community-celebration arts events, such as the Fremont Summer Solstice Parade in Seattle. My most recent series captures the point of connection of nature in the city; the places where water, trees, and light go about their business, often unnoticed, amidst the hustle and bustle of the concrete jungle.

I take great pleasure in spreading the joy of low-tech photography though workshops and lecturing. My home is currently in Seattle, but my heart also has a place on Vashon Island.

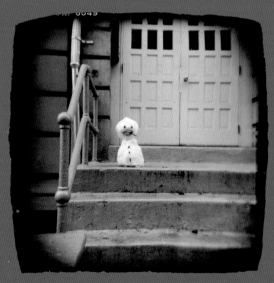

Snowdude, © Michelle Bates, 1992.

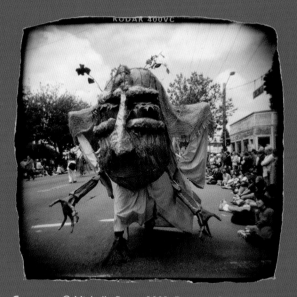

Greenman, © Michelle Bates, 2003, Fremont Summer Solstice Parade.

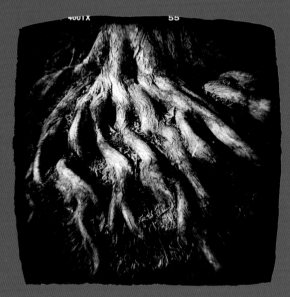

Roots, Boston Public Garden, © Michelle Bates, 2005.

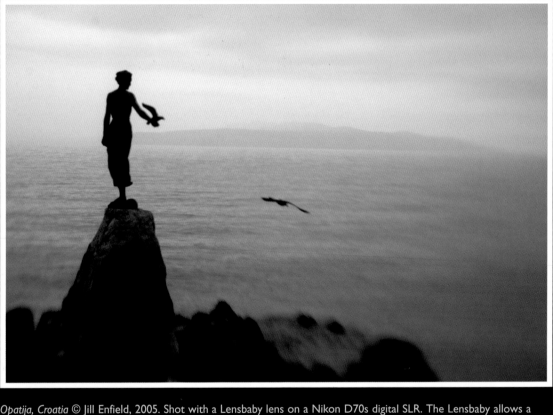

Opatija, Croatia © Jill Enfield, 2005. Shot with a Lensbaby lens on a Nikon D70s digital SLR. The Lensbaby allows a select area (even off to the side) to be in focus, with all else going to blur.

chapter three

That's *So* Cute! The Cameras

Everywhere I look lately, I see toy cameras. Not just the old standards, but new styles and versions that are being released all the time. Toycam Handbook, published in 2005 by the toycamera.com community and Light Leaks Press, has a comprehensive guide to toy cameras, complete with photos and specifications of 37 models. It is the place to go to find out if your $1 yard-sale find is in fact a precious gem. In this chapter, I'll provide information on a few of the most popular types of plastic cameras, as well as some other cameras and lenses that aren't pure plastic, but still bring out the joy in photography.

THE HOLGA

The rest of this book details how to use the Holga (although much of the information is relevant to other cameras as well), and how its quirks affect the shooting experience and the images that result.

All Holgas have the same basics. The spring shutter delivers a shutter speed of approximately 1/100 of a second. The aperture is somewhere between f/11 and f/13, and is not changed by moving the aperture switch. The Holga's "optical lens" is a single-element, uncoated lens, with focus setting ranging from around four feet to infinity. While the Holga may seem like a simple tool (and it is), there are several models from which to choose. The history of the Holga is covered in Chapter 1; here is a rundown of what styles are available and their differences.

- Holga 120S and 120SF. In production from 1982–2005, the original Holgas came with a hot-shoe (120S) or built-in flash (120F). This design was produced for over 20 years and vaulted the Holga to world-wide fame.
- Holga 120N. The current flagship model retains the classic spring shutter mechanism, but adds a bulb setting (which allows for long exposures) and tripod socket.
- Holga 120FN and CFN. These new versions have built-in flash, with the CFN model also sporting a rotating series of colored filters in front of the flash.
- Woca 120G and 120GF. These are the current versions of the Holga that feature glass, instead of plastic, lenses. They may look like Holgas, but aren't really part of the plastic camera club.
- Holga 35 AFX. Yes, you can actually have a 35 mm companion Holga, but it takes batteries; how un-toylike! These are similar to the many simple 35 mm cameras available today, which make photography affordable, but don't necessarily bring a different look to the images. They bear no resemblance to classic Holgas.

- Holgamods. Since 2000, Randy Smith, the man behind Holgamods, has been customizing Holgas to expand their capabilities. His basic modifications include painting the interior flat black to decrease light bouncing around in the camera (called flocking), adding two true apertures, a higher quality bulb setting, tripod port, and closer focusing

The Holga 120N with a Holgamods version. It has a bulb setting (accessible even when mounted on a tripod), cable release, waist-level viewfinder, and a step-up ring screwed into the lens barrel for attaching filters.

capabilities. For additional fun, he can add a waist-level viewfinder, color to the camera body, and a cable release. While many people play with their Holgas, Randy has made his improvements available to everyone, and he continues to come up with new ideas. For more information, along with tips and images, go to www.holgamods.com.

THE DIANA

While this book focuses on the Holga, as it's still being manufactured, the reverse technology movement truly began with the Diana (as detailed in Chapter 1) in the late 1960s. Dianas were made in two versions: the standard Diana and the Diana-F version, which takes an external flash unit that uses old-style disposable flash bulbs. Starting in the 1970s, many different brands of almost identical cameras were made, with a multitude of names and of varying quality. These include Arrow, Banner,

and Future Scientist, to name but a few (see Allan Detrich's website for his near-complete collection, with images, at www.allandetrich.com/diana.htm). Though highly collectible Dianas and the clones are still actively used, these days they go for a lot more than $3 on eBay. But they still crop up at yard sales and thrift stores once in a while, so happy hunting!

Dianas, like Holgas, have quirks which endear them to many photographers, and frustrate others. Dianas are by far the leakier of the two, so more taping around the body seams is necessary to keep images from getting streaked. Most Dianas came with bulb settings, but no tripod outlet, so other ways have been invented for keeping the camera still during long exposures. One way is to glue a quarter-twenty nut to the bottom of the camera, but since Dianas are hard to find, some may not want to alter theirs. Other Diana owners have created wooden brackets that they then attach the Diana to with rubber bands.

Dianas create sixteen 4 cm × 4 cm images per roll of 120 film, leaving a considerable amount of unused area on the film. They have three apertures, pictured in front of the lens as cloudy, partly cloudy, and sunny. These measure

A Diana-F and Dories camera with flash unit in their special toy camera suitcase.

out to around f/11, f/13, and f/19. Dianas images are softer and the cameras more delicate than Holgas, but each photographer has his or her own visions, and many treasure their aging Dianas.

THE FUJIPET

This rare beast is a stunning exam-ple of great design and beautiful image-making. The Fujipet was manufactured in Tokyo, Japan by the Fuji Photo Film Company from 1957–1963, and came in a variety of body colors and styles. Although hard to find today, they are sturdily built and have held up well over time. These plastic-lensed toys use 120 film and make 6 cm × 6 cm square images, which look like a cross between a Holga and a

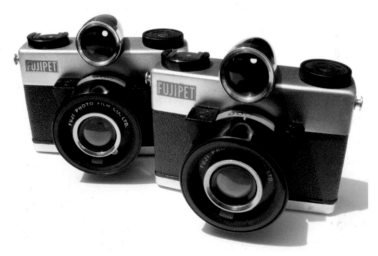

A pair of Fujipets. Image courtesy of Skorj, © 2006.

Diana. See the portrait of the Holga's inventor on page 8, taken with a Fujipet.

LOMO

Lomo's flagship model, the LC-A, may not have a plastic lens, or be particularly cheap, but it is very popular and holds a special place in the world of toy cameras. These 35 mm cameras (which are currently out of production, although Lomo is trying to change that) sport a decent glass lens, and

sell for about $200, but the Lomographic Society makes every effort to create the toy buzz around them and its other more toylike products. Lomo continually feeds the toy camera community with new cameras to play with, including the Action Sampler, the Super Sampler, the Pop 9, and several accessories to the Holga.

The Lomo website is enormously popular, and brings many people into the toy camera fold who otherwise wouldn't know what to make of a Holga or Action Sampler. Lomo has created the Ten Golden Rules of Lomography, to help lomographers (as they're called) "shoot as many impossible pictures as possible in the most impossible of situations from the most impossible of positions." Their main tag line is "Don't think, just shoot," providing photographers a manifesto of fun.

The Lomographic Society has created a new angle on the natural congregating that tends to happen among toy users. Since 1994, Lomo, based in Europe, has thrown Lomo parties and events all over the world, including the LomOlymPics. Lomo-crazed photographers are sent out on missions of documentation, encouraged to not actually look through the lens when they shoot, and are rewarded with exhibits made up of thousands of images, along with all-night parties.

The society regularly produces publications of images made with their stable of cameras, and the website (www.lomography.com) provides an enormous number of opportunities to post images, chat online, and collect the latest in cameras or related gear.

The Action Sampler from Lomo, with their specially packaged film.

MULTILENS CAMERAS

The newest rage in the toy camera world is cameras that have multiple lenses (whether with plastic or glass lenses—it can be hard to tell sometimes). These create negatives that combine several images (2, 4, 8 or 9) onto one 35 mm frame. The negatives can be processed and printed by standard labs, and the Lomo website allows photographers to upload series and then creates animated MiniMovies.

Action Sampler — Four lenses fire in rapid sequence. Another version sports four flashes, which fire in time with each of the lenses.

Nickelodeon Photo Blaster — Four lenses, each triggered individually, create a series of images on a 35 mm frame. If you can keep track of which frame you're on, it's possible to choreograph interesting composites. Produced until 1999.

Oktomat — Eight lenses fire sequentially over 2.5 seconds, forming a grid of images that can be printed, or animated into a (very) short film via the lomography website.

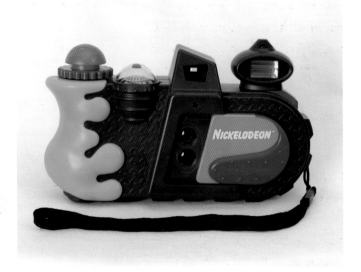

Nickelodeon Photo Blaster.

Pop 9 — Nine 24 mm lenses fire at the same time, creating a 3 × 3 grid of identical images per 35 mm frame.

Quad Cam — The queen of the quads, this gem gives you the choice of shooting each lens individually, making two or four identical images, or shooting all four sequentially at three different speeds. All result in four images per 35 mm frame.

Split Cam — This very simple camera has little blinders that cover half the frame at a time, allowing the photographer to merge two scenes in a fuzzy border down the length of the 35 mm image.

Ocean I, © Michael Sherwin, 2005 from the *Momentum* series. Action Sampler image, 36″ × 48″ archival digital print. Sherwin assembles a whole roll of images randomly in Adobe Photoshop® to create his collages.

Super Sampler — Four wide 20 mm lenses fire sequentially, producing four vertical panoramic stripes per 35 mm frame. You can choose to have the lens complete the 4 shots in 0.2 or 2 seconds.

ANSCO PANORAMIC

These 35 mm cameras don't stretch the size of the image to a true panorama; they simply cut off the top and bottom of the frame. But the plastic lens is a wide 20 mm, unusual for a cheap camera. Many similar types of cameras are floating around.

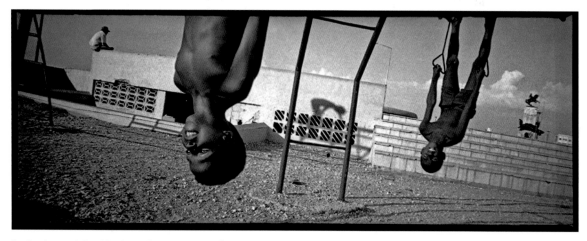

La Sombra y el Caudillo, Serie Centra Habana, © Francisco Mata Rosas, 1998. Ansco Panorama photograph made in Cuba.

HYBRID CAMERAS

Plastic cameras are a blast to play with. Like many toys, part of the fun can include taking them apart, combining them with other cameras, or adding new foreign part to them. Many photographers become much more adventurous with a $20 camera than they would be with, say, a $2000 Hasselblad. But sometimes the difference gets jumbled in a poor photographer's brain, and he may want to mate the two. Holga and the Diana lenses have been mounted onto other medium-format cameras and even large-format view cameras. Some photographers have inserted shutters from other cameras, with the full selection of shutter speeds, between their plastic lenses and camera bodies. With a teeny screwdriver and a passion for innovation, the intrepid photographer can create unique cameras that create equally unique images.

NOT QUITE PLASTIC

While most plastic cameras qualify as toys, not all toy cameras are made of plastic. Part of the charm of toy cameras is their look and feel, both to the photographer and the subject, and qualities of the images that come out of them. So while the main focus of this book is on our plastic camera pets, there are many other cameras out there that break through the traditional barriers that cameras can create between the wielder and the subject. These affordable "playthings" often evoke a smile and exclamation: That's *so* cute!

The Lensbaby

The Lensbaby is a strange hybrid animal. A Lensbaby on a Nikon, Canon, or other 35mm SLR is a contraption that could be the offspring of a Holga and a view camera, and creates high-quality

negatives with an off-beat flair. The Lensbaby's lens is made of glass, but its form and function offer the photographer an entirely new way to interact with the camera. This combination is the easiest way to get plastic camera–style images into a digital camera.

The Lensbaby is a lens mounted on a flexible free-wheeling mini-bellows, adjustable by pulling, pushing, and tweaking back and forth with extended fingertips. This give the photographer total control on what area of the image is in focus (called the sweet spot), while the rest of the frame blurs out towards the edges. The size of the sweet spot versus the surrounding blur can be changed by swapping out aperture rings; at maximum aperture, you get maximum blur.

The original Lensbaby's lens is a simple, uncoated glass optic, with aperture rings that sit in front of the lens and are changed by fishing them out clumsily with a plastic stick on a chain. The newer Lensbaby 2.0 is even less of a toy, with a higher-quality glass doublet lens, a faster 2.0 maximum aperture, and a relatively high-tech magnetic aperture ring setup. Lensbaby versions are made to fit on all the major 35 mm bodies.

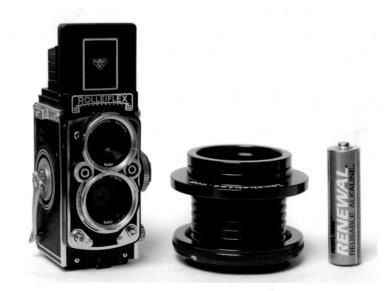

In the world of cute cameras, the Rolleiflex MiniDigi and Lensbaby never fail to elicit oohs and ahhs. The AA battery shown is just for scale since the MiniDigi uses a CR2 battery.

blue rascal smiles, © ;-p r a b u!, 2005. Shot with a Lensbaby 2.0 lens using a +4 macro filter on a Nikon D70 digital camera.

The true charm of this lens is in showing it off to others by giving one side a pull, and letting it twang back and forth a few times. But, like anything else, the truly great images come from the vision of the photographer, not from the equipment.

The Rollei MiniDigi

The world of digital photography is finally discovering the joy of the cute factor. With the MiniDigi, Rolleiflex proves that somewhere in its hallowed halls, someone has an excellent sense of humor. The MiniDigi, a teensy (2¾″ high) replica of Rolleiflex's flagship twin-lens reflex camera, also happens

to be a working digital camera. It may not have as many features as most digital cameras on the market (in fact, it may have fewer than any other), but it may be the only one that can be worn as a very stylish fashion statement. And, while the lens is glass, it gets more smiles than any other camera I've ever used, and inspires everyone to fondle it, gaze down at the miniature LCD screen, and try taking a picture with it. Who wouldn't be charmed to see the word "WELCOME" scrolling across the teeny screen when you turn the camera on?

If you can live with two megapixels, no exposure adjustments, and having to remember to crank the wee handle between exposures, this toy will be the star of your camera collection and your jewelry box! However, making great images may be tricky, as this camera is even less predictable than a Holga, with its built-in meter making all the calls and no adjustments possible. Another element it doesn't share with the plastic cameras is price; this replica sells for $200 and up.

In the same vein, Leica and Minox have teamed up to produce the tiny Minox Classic Leica M3 4MP (under $200), another adorable replica of a landmark film camera. Other digital toy cameras include the Jamcam and Digipix, which Nancy Rexroth, the original Diana camera star, has taken up, with great success.

The MiniDigi flies in over Seattle, capturing Lake Washington, Mercer Island, and Mt. Rainier, © Michelle Bates, 2005.

Pixelvision

Sometimes it's necessary for grownups to raid the kids' stores to discover new tools for artistic discovery. Such is the case with the Fisher Price Pixelvision PXL-2000 video camera, the film and video world's answer to the Diana. This toy records super low-quality video onto cassette tapes. Made only from 1987–1989, these are collector's items to some, working tools to others. Each year, films made on a PixelVision are shown at the PXL THIS Film Festival.

Cell Phone Cameras

Who doesn't have a cell phone with a camera feature these days? That makes everyone a potential photographer! These teensy cameras (that sometimes even have flash) are used to capture images of our friends to appear when they call, or they function to snap a picture of something interesting or important when there are no other cameras on hand. But they can also be used as serious photographic tools, both the older, lower quality ones, and the newer, more sophisticated versions. Robert Clark, a regular photographer for *National Geographic*, was sponsored by Sony Ericsson to take one of its cell phones around the United States. The result was a book called

Red Bookcase, © Nancy Rexroth, 2001, Cincinnati, Ohio. The Digipix camera contributed the crayon-like effect; color was played with in Adobe Photoshop®. Another Digipix image by Rexroth is on page 17.

Image America. It's hard to tell that these images weren't made with a "real" camera, but the difference for him was in the experience.

Pinhole Cameras

A book that focuses on low-tech photography could hardly omit a reference to pinhole photography, the oldest and most basic type of image-capturing. Pinhole cameras, of course, have no lens at all. Images are transmitted from the outside world into a light-tight box through a tiny hole, and feature infinite depth of field. These cameras can, and have been, made from any size container, from a matchbox to a barn.

The world of pinhole photography is very much alive, with books, online communities, and exhibitions regularly spurring its practitioners on. And the level of creativity and skill put into their photographs is remarkable. PinHolgas are a hybrid of the pinhole and plastic camera worlds. See Chapter 8 for details.

While we've covered a few special cameras here, don't feel limited to just these. Any camera can be made to produce fabulous images because, as we can never say enough, it's the photographer who creates the images, not the camera.

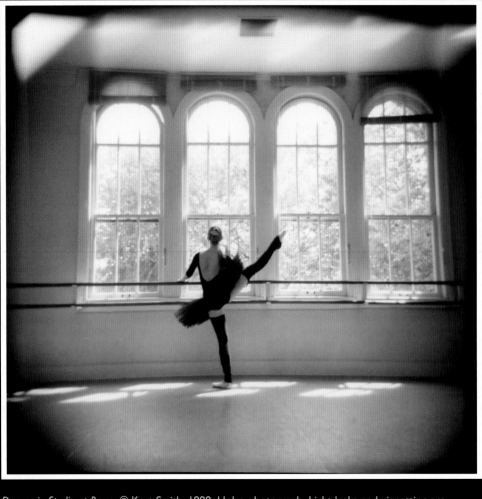

Dancer in Studio at Barre, © Kurt Smith, 1998. Holga photograph. Light leaks and vignetting are classic Holga effects.

chapter four

I Got Me a Toy Camera—Now What?

At this point you may be wondering, if this camera is so low-tech, why do I need help using it? Holgas are quite simple, but they have many quirks that affect their use and the look of the images. As with any camera, the more you know about how your Holga functions, the better you'll be able to make it work for you to make images that match your personal artistic vision. In this chapter, I'll guide you through the main issues you'll need to know to gain control over the Holga's peculiarities. Once you know what they are, you can choose how you'd like to proceed; some photographers want to banish any unpredictability from their shooting experience, while others welcome it.

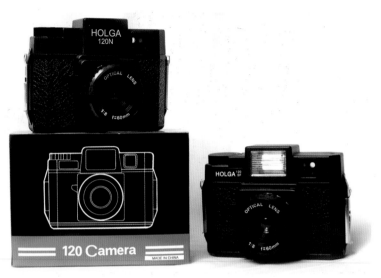

The Holga family: the current 120N and an original 120SF. The Holga N family includes the 120N, 120FN, and 120CFN, with a color flash. All have a bulb setting and tripod port.

Holgas don't have many adjustable elements, like other cameras do. Expensive interchangeable-lens cameras allow the photographer to fine-tune almost every aspect of how light enters the camera, or, as point and shoot models do, they can use sophisticated meters and electronics to make the adjustments for you. The amount of light that the Holga captures with its minimalist spring shutter, on the other hand, is consistent from frame to frame, so the onus is on the photographer to understand how to work with that limitation to his or her advantage. Modifications (discussed in later chapters) allow photographers to expand the Holga's range, and the type of images it can produce.

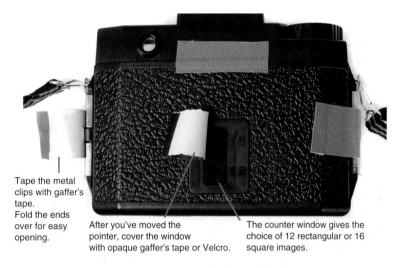

Tape the metal
clips with gaffer's
tape.
Fold the ends
over for easy
opening.

After you've moved the
pointer, cover the window
with opaque gaffer's tape or Velcro.

The counter window gives the
choice of 12 rectangular or 16
square images.

Start getting your Holga in shape to shoot with some tape here and a push there. Refer back to this figure throughout the chapter to see how to tweak your Holga.

You'll want to experiment with the different effects Holgas produce; the discovery of the unique images you can create is part of the joy of shooting with toys!

IMAGE FORMATS

Holgas use the versatile 120 (also called medium format) film, and can be used to produce images in two different formats: 6 cm × 6 cm squares, or 6 cm × 4.5 cm rectangles. Most photographers shoot the larger size, which creates the Holga's special look of a sharp center and corners that fade into darkness and fuzziness. This shape can be obtained by either using the square format plastic insert in

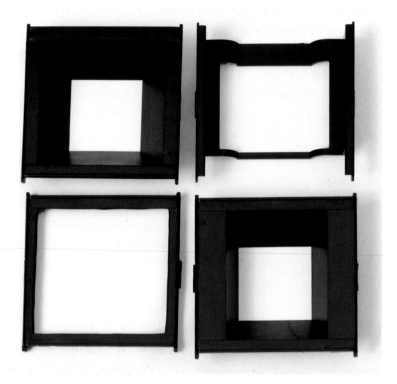

A variety of inserts are now made for the Holga, or file one out yourself.

the camera, or by not using any insert. The smaller framing is created by using a different insert which masks the film to the rectangular shape. This format has the advantage of allowing 16 frames per roll of 120 film, compared to 12 in the square format, but loses the fuzzy corners that make the images recognizable as plastic camera shots.

To set the Holga up to shoot in either of these formats, you need to set the film counter window, on the camera back, to the appropriate setting. When shooting square, make sure the pointer is facing the number 12; to shoot rectangles, move it to point to 16. On older Holga models, this window can be very difficult to move. Get a butter knife or other flat tool, and firmly push the window up or down, being careful not to break through the red window. With the introduction of the Holga N series, this window has been loosened up, making this process much easier.

The plastic inserts do more than just change the format of Holga's images. They also block some light leaks and press the film against the back of the camera, which makes the images a bit sharper and tightens the film on the spools. In Holgas with built-in flash, they also hold the batteries in place; if you want your images to have as wide of a frame as possible, special inserts are available that hold the batteries down without blocking the view. It's not necessary to use any of these inserts in your Holga at all; I never do. The problems this creates can be fixed with a few little tweaks, as discussed in the following sections.

LIGHT LEAKS

The first thing many photographers think of when you talk about plastic cameras is light leaks. Ah, light leaks. Some shooters love them, some hate them. Dianas tend to make images full of streaks from leaks all over the camera. To get clean images with a Diana, it is necessary to tape all the seams and other parts that don't fit together well enough to keep out the light. Holgas are made to a somewhat higher standard, so they don't have as many problems with light coming in where it's not wanted. There are a few areas that will leak though, if not taken care of.

Before you begin, get yourself a roll of black gaffer's tape. This tape is strong, opaque, easy to tear by hand, and can be peeled back and restuck many times without getting goo all over your camera. It is the king of tapes, and while it is pricey, one roll will banish light leaks from many Holgas.

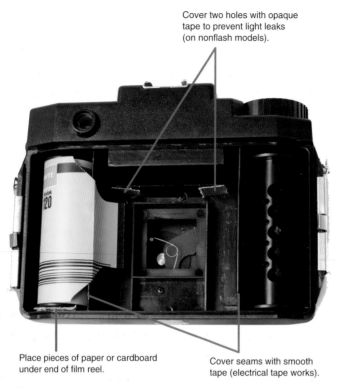

Cover two holes with opaque tape to prevent light leaks (on nonflash models).

Place pieces of paper or cardboard under end of film reel.

Cover seams with smooth tape (electrical tape works).

Follow this guide to fixing up the inside of your Holga.

When you use a Holga 120S or 120N, there are two holes that will spill light onto the top of your frame if you shoot without an insert in the camera. These holes provide a conduit for the flash wiring on built-in flash models, so aren't a problem if you have a 120FN, 120CFN or 120SF. Using the diagram above to help find them, cover the holes with opaque tape, and once that's done, you can forget all about them.

Cover That Window

Another area that may leak light is the red counter window on the camera back. While the red filter and the paper backing block most ambient light from reaching the film, very bright light can blast through these barriers. This can create unwanted patterns on your images, including imprints of the text that is printed on the film's paper backing. To prevent such leaks, keep this window covered with black gaffer's tape, with one edge folded over for easy lifting (see diagram on page 97). Only uncover the window when you are advancing the film, preferably in subdued light; if it is bright and sunny out, turn so the camera is in your shadow. Other ways to keep this window light-tight, while still allowing easy access, include Velcro flaps and sliding plastic covers. For more tips on these methods, look online, or experiment.

Keeping the Back On

Another quirk of the Holga that can lead to not just light leaks, but several ruined frames, is, believe it or not, the tendency of the camera back to fall off. The metal clips that hold the Holga back on are very weak, and are continually pulled on by the camera strap, which connects to holes at the top of each clip. I once experienced this catastrophic failure as I ran full speed through a parade I was photographing, hearing plastic bits bouncing behind me on the pavement. Several frames were ruined, and I had to stop to pick up the pieces of my camera in front of several thousand people!

Fortunately, this is easily prevented using more gaffer's tape. Tear off two four-inch long strips of gaffer's tape, and fold one end of each over about ¼ inch. Wrap each one around the sides of the camera, over the metal clips, placing the folded ends on the back of the camera, for easy lifting of the flaps when changing film. Sticky Velcro strips can also be used to hold the back on, or even

rubber bands. The clips themselves can be tightened somewhat by bending down the tabs that set into the plastic grooves. Some photographers get away with just this, but I wouldn't trust it completely.

Roll It on Tight

The Holga doesn't always do a great job of what should be a simple task—rolling the film from one reel to another. As frames are shot, film is wound from its original spool onto the empty take-up spool, located on the right side of the camera. Often though, there isn't enough tension to keep the film and paper backing rolled tight, and loose winding allows light to leak into the edges of the roll after it's removed from the camera. These light leaks create streaks coming in from the edges of the film at the end part of the roll.

There are a few ways to help prevent these "fat" rolls. Newer Holgas come with foam pads that press against the new and take-up reels to increase the tension. The plastic inserts help with this as well, and can keep the film from rolling on at an angle, which can also cause film to roll up over the edge of the reel. The best prevention for this is to add tension under the new roll of film by jamming bits of paper or cardboard between the bottom of the reel and the wall of the camera. Pieces of film boxes, or the paper tape that comes wrapped around the film, both work well. Experiment with the amount of material to stuff into the gap; too much will jam the reel and make it impossible to advance the film. More elaborate and permanent shims can be made with folded

pieces of plastic or thin metal. No method is perfect, but these tips will help decrease the frequency of poor rolling.

Even with precautions, film will roll on off-kilter occasionally. The key to saving your precious images, is being able to feel when there's a problem before opening the camera back. When the film does roll on loosely, or up onto the edge of the reel, it will often become difficult to turn the advance knob. When you feel this, either take your Holga to a light-tight room, or put it into a changing bag. This is a zippered opaque bag with elastic armholes that allows you to manipulate the camera and film in darkness, and is small enough to throw in your camera bag.

Once the camera is in darkness, take off the back, and remove the film. If you find the film is wound on loosely, take hold of the paper end and pull the film tight, while turning the spool until it is as compact as possible. Then you can remove it from the bag, lick the white strip, fold the end tab of the film under, and seal it tightly shut.

If time is too tight to pull your film taut, you'll want a light-tight container to put your vulnerable film into for the time being. After taking the film out of the camera in darkness, place it into a 120 film canister (see the following figure for options), or wrap it in foil. When you have access to a light-tight space at a later time, pull the film tight and seal it, or, if developing the film yourself, load it directly onto processing reels.

If the occasion arises (and it will!), when you think the film has rolled on okay, but open the back to find that it has not, slam the camera back shut right away. If you don't have a changing bag, under your coat or in a dark closet can do for a quick transfer to a light-tight container. Many photographers try to avoid light leaks by always unloading in a changing bag.

120 film spools make great holders for extra gaffer's tape. Make your own
120-film canisters by cutting the bottom off a 35 mm can and taping it onto a
second one with opaque tape, or buy specially made ones from J and C Photo.

DON'T SCRATCH MY FILM

If you're not using an insert inside your Holga, there is one more thing to consider. On the surface of the interior dividers that the film passes over are seams that can ruin your film—they may create scratches that extend horizontally across the whole or part of a roll. Cover these divider edges with a smooth tape like electrical tape (black) or thin foam for a nice resting surface for your film (see figure on page 100).

CHUCK THE LENS CAP

Unless you have experience shooting with a rangefinder camera, you will want to get rid of the Holga's lens cap. Like rangefinders, the Holga's viewfinder is separate from the lens; when the cap is on, you can still see through the finder, compose and shoot, and only later realize that no light was able to reach the film. The one use I've found for the lens cap is to keep the lens barrel covered while skiing; once I tumbled down a ski slope and the lens barrel became packed with snow, which was pretty hard to clean out and dry off wearing ski gloves! Yes, without the lens cap your lens will get dusty over time; just wipe it with a soft cloth once in a while. It is set so deeply in the lens barrel that scratches aren't really a problem. And hey, if something happens to the lens, the whole camera costs less than a protective filter for a real camera!

Now your Holga is ready to roll!

Sand & Water, © Gordon Stettinius, 2003. Diana camera image on black-and-white film.

chapter five

Feeding Your Holga

FILM CHOICE: WHAT FLAVOR OF FILM?

Holgas and Dianas use 120 film, also called medium-format film, which comes wrapped around plastic reels about 2¼″ tall and have a paper backing along the whole length of the film, with extra paper at each end.

Be careful not to confuse 120 film with 220 film, which looks the same, but has twice the length of film and the paper only at the ends. It is not usable in Holgas or Dianas, because we need the numbers printed on the paper backing to know how far to advance the film between shots. Roll film comes wrapped in foil, leading my non-photographer friends to think I always have candy stashed in my pockets (which may also be the case). You can use black-and-white, color negative, or transparency film in toy cameras, but their limitations may affect your film choice.

For most plastic camera shooting, I recommend color or black-and-white negative film. Negatives give you lots of exposure latitude (the ability to capture a wide range of tones), and the flexibility to tweak an image later, in the printing stage. Negatives that are over- or under-exposed can often still create good final images (see Chapter 11).

When considering which film speed to use, remember that Holgas have a single-setting spring shutter (~1/100 s) and one aperture (~f/11), so you can't adjust the camera's settings to the lighting

A selection of 120 film.

circumstances. The bulb setting that some versions sport, which allows for long exposures, is not easily controllable or repeatable. It usually results in too long of an exposure for daylight shots, but is very useful in low-light situations. So the main thing you can do to make sure you get enough exposure to make good images is to choose a fast enough film. ISO 400 is a great general shooting speed. You can also use faster films; speeds of up to ISO 3200 are available, and you can adjust the processing with some of these to get film speeds through the roof!

With transparency film, the film itself is the final product, so correct exposure is critical. Transparency film (and slower speed negative films) can be used in situations where you can adjust your light input, for example when using a Holga or Diana with a bulb setting, on- or off-camera

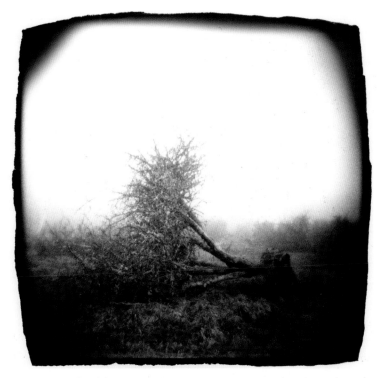

Wax Orchards Tree, © Michelle Bates, 2005. Holga image taken with Ilford
Delta 3200 film on a very foggy morning.

flash, or studio strobes. Handheld light meters can be helpful in determining the level of available light. There will be more on these options later in Chapters 7 and 8.

Many people are surprised that Holgas and Dianas shoot color. In fact, Holgas make wonderful color images, and the final prints you produce can be gorgeous if you continue the chain of control

by doing your own color printing. There are many types of color film available that can create a range of moods and feelings in your images. Portrait films reproduce slightly muted colors and good skin tones. Super-saturated films make colors pop to create sometimes unreal results. Results can be even more personalized using techniques such as cross-processing and hand-coloring. Experiment with your preferences and subject matter to get results you love. Even with the limitations of Holgas, Dianas, and other plastic cameras, don't be afraid of shooting when the light isn't perfect, or you don't have the right type of film in the camera. Poor negatives may be a challenge, but a lost moment is lost forever.

FILM TYPES
Black and White Film

Traditional black-and-white (B&W) films can be processed at home in any sink, or given to a lab. Not all B&W films are available in 120 size, but there is still quite a variety. Kodak Tri-X Pan 400 is an ideal choice for plastic cameras, but also consider Kodak Tmax 400, Ilford HP5, Ilford Delta 400, or other 400-speed choices. These can all be pushed to achieve greater speed, but for the most possible light sensitivity, use the one-of-a-kind Ilford Delta Pro 3200, the only B&W film faster than 400 that comes in 120 size. It can be rated from 400 to 6400, and even higher with special developers. For slower B&W films, there are many choices. Freestyle Photographic and J and C Photo specialize in hard-to-find films and offer some new and off-beat options.

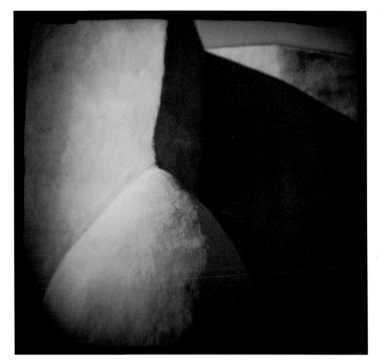

Ranchos de Taos Church, © Robert Owen, 1992. Diana camera image, gold-toned, silver-gelatin print. Standard black-and-white prints can be modified with a variety of toners.

Infrared Film

For those wanting to combine Holga's signature style with an alternative look in film, there are two types of infrared (IR) films available in 120: Macophot IR820c 820 nm and Rollei Infrared 400. See Chapter 8 for more information on shooting with these films.

Black-and-White C-41 Film

Ilford XP2 and Kodak BW400CN are specialty films that produce monochromatic negatives, but are processed in color (or C-41) chemistry. The magic of these films is that you get beautiful black-and-white negatives, but they can be taken in for processing to any color lab that can do 120 film. If you don't process your own film, don't have access to a local lab that runs black-and-white (they are less and less common these days), and don't want to send precious images in the mail, these films may be your best option.

Both the Kodak and Ilford films are ISO 400, and have wide latitude, meaning they capture a wide range of tones. Negatives from either film can be used to make prints in a lab's color or a home black-and-white darkroom, although, according to the companies' specifications, the Kodak BW400CN is optimized for printing on color paper, while Ilford XP2 is meant for printing on standard black-and-white paper. These wonderful films expand your shooting options and processing possibilities greatly.

Color Negative

As film sales plummet, with the rise in the use of digital cameras, the selection of color 120 films is dwindling, but luckily, there are still several good choices available. Kodak's selection is the widest, with Fuji pulling in second. Kodak's Portra series has eight flavors, including NC (natural color), VC (vivid color), and UC (ultra color), in various speeds. Fuji also has a number of choices, and several other brands of color negative film come in 120 size; experiment to see which color balance and intensity suits your shooting style. Speeds from 100–800 are available (faster 120 color films used to be made, but things change quickly in the photography world); keep an eye out for new faster versions.

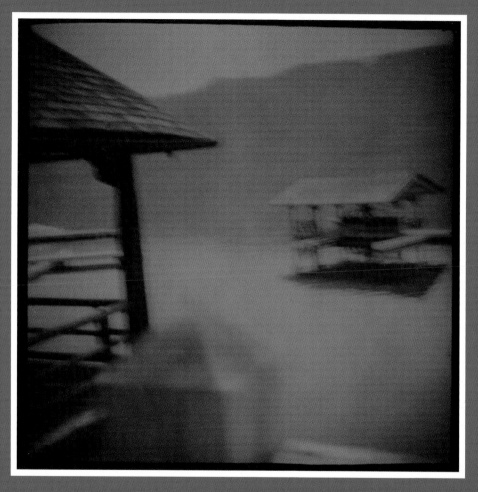

Silver Bay Boathouse, from *The Adirondacks*, © Mary Ann Lynch, 2001. Diana camera multiple exposure on Fujicolor NPH 400 professional color negative film.

A Selection of Color Films Available in 120

Film Speed	Kodak	Fuji
800	Portra 800	800Z
400	Portra NC, VC, and UC	Pro 400H
160	Portra NC and VC	Pro 160C (vivid)
		NPS 160 (neutral)
100	Portra UC	Fuji CN Reala
	Portra 100T (tungsten)	

Transparency

Transparency film, also called slide film, is tricky to use in a camera that has very little in the way of exposure control. But it is perfectly able to be run through a Holga if you're up for a challenge. Chapter 7 offers several tips to increase control over your exposures, vital for shooting transparency film.

Fujichrome Provia 400F (RHPIII) and Kodak EPL Ektachrome 400X are currently the only fast choices in 120. For ISO 200 and below, there are several options.

Cross-processing

Another way to add some unpredictability and a special look to your toy camera experience is to cross-process color film. Transparency film (normally E-6 processing) can go through color-negative chemistry (C-41), and vice versa, to achieve a variety of strangely-colored results.

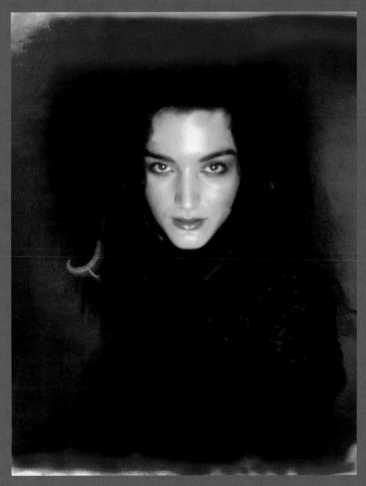

Beauty Zoya, © Pauline St. Denis, 2002. Holga camera image made with a ring strobe around the lens on transparency film.

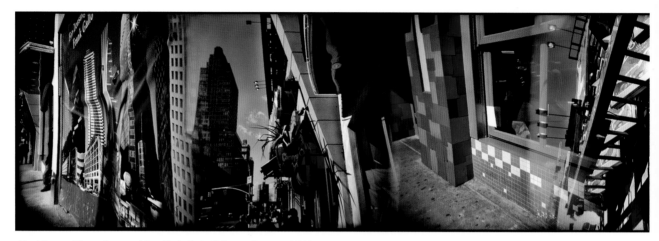

42nd Street (Times Square, New York City), © Susan Bowen, 2002. Holga multi-exposure panorama with cross-processed tungsten transparency film.

35mm Film

Even though it's made to use 120 film, you can also load up a Holga with 35 mm film. With this smaller film, the images are wide panoramic shots that bleed right out to the edge of the film, including the sprocket holes in the image. See Chapter 9 for details. There is a far greater variety of 35 mm films available than 120!

Polaroid Film

A short-lived addition to the Holga collection of accessories was the Holga Polaroid back, sadly discontinued in 2006. This custom-made film back slips right onto the Holga and locks in place

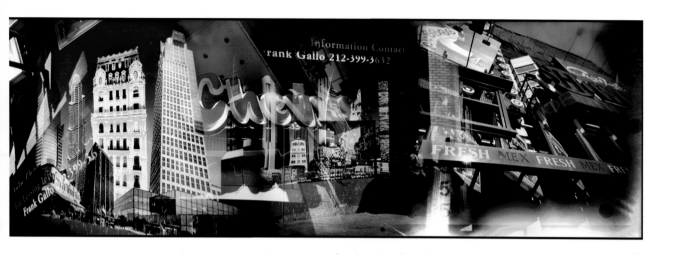

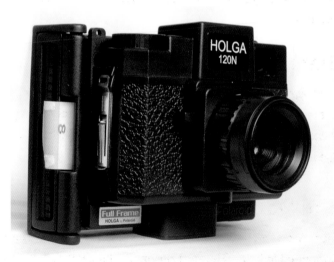

A Holga with a Polaroid back isn't a graceful thing, but it sure is fun to play with! A diopter lens (included with the back) must be used over the lens to correct the focal plane for proper focus.

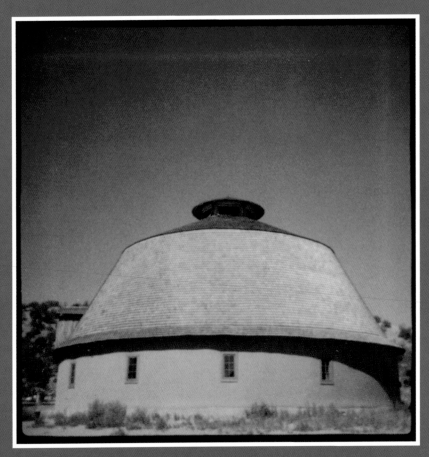

Round Barn, Ojo Caliente, New Mexico, © Michelle Bates, 2003. A Holga Polaroid image made on an early version of the Polaroid back that wasn't full-frame.

with the same metal clips that hold the back on. The back takes Polaroid 80 series films, which are also starting to be discontinued. These distinctive backs will probably remain available through eBay or other resellers, but keep checking the recommended retailers in the Resources section for film availability. For more information about shooting Polaroids with your Holga, see Chapter 8.

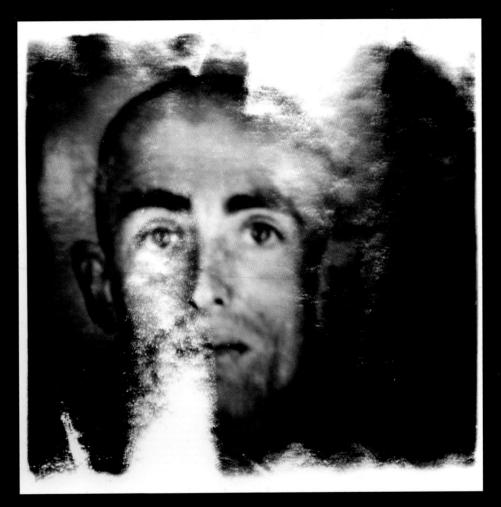

Auschwitz, Poland, 1999, © Michael Ackerman. A Holga camera image showing significant light leaks from the edges of the film.

chapter six

Let's Get Shooting!

Loading and unloading a Holga takes a little getting used to. Once you get the hang of it, it's still slow and clumsy, but, hey, so is loading a Leica! Always keep the camera in subdued light (such as your shadow) when loading and unloading, and use the following instructions as a guide to getting film into, through, and out of your Holga. See Chapter 4 for additional information about preparing your Holga to minimize light leaks.

LOADING THE FILM

A new roll of film gets loaded in the left side of your Holga. There should be an empty spool on the right side; once you've run film through, you'll have to move the empty spool from the left side to

the right after each roll. If you're missing an empty reel, load one from a stash of spools that you should keep just for this purpose. If you process your own film, keep some spools around (take the rest to a lab for recycling); otherwise your local processing lab should be able to supply them. In a pinch, you can sacrifice a new roll of film for the spool—it's better to waste some film than to miss a golden shooting opportunity!

Now back to loading your film. Insert the reel into the top left lug with the paper rolling off toward the right. You may need to rotate the reel until it catches, then press it down. Insert cardboard or plastic pieces under the bottom of the reel to keep things tight (as detailed in Chapter 4). Keeping your thumb on the lower part of the new reel, pull the paper backing to the right, unfold the narrow paper tab, and insert it into the slot in the center of the empty spool. Lightly holding the paper against the right-hand spool, wind the advance knob until the paper is taut and it seems like it will stay on the reel. If you have trouble getting it to catch, tape the end of the paper tab to the empty spool, making sure the tab is centered. Once the film has caught, keep a little pressure on the lower part of the film reel, wind the advance knob a couple of times. Replace the camera back, close the clips, and close the tape flaps to keep the clips secure.

Now the film can be advanced to frame one. Pull back the tape covering the red counter window, and start winding the film advance knob while watching the window for the number that will eventually appear. Different brands of film have different printing on the backing paper, but the general idea is to keep turning until you see a number one (1), which may be upside down. This takes a while. Go slowly the first time until you know what you're looking for; all films have markings on the paper backing designed to warn you when the next number is coming up so you don't go flying past it. Once you start shooting, you'll figure out the system of your film; Kodak has text leading up to the numbers, while Ilford prints a series of dots that increase in size before the number appears (these

dots are very faint through the red window, making using Ilford films quite a challenge, especially at night!). Once you see the "1," your Holga is ready to go!

SHOOTING

To make an exposure, release the shutter by pressing the lever next to the lens downward. Hold the camera steady; it takes a little effort to click and it's possible to blur an image or change your composition by moving the camera. To get ready for your next shot, wind the film advance knob until the next number appears in the window. I find it takes about five turns of the knob (not all the way around—it's just how I happen to grip it) to advance one frame in the square format.

Remember, the Holga is not a smart camera. It will let you keep shooting even if you never advance the film, making double, triple, and quintuple exposures! It's up to you to remember to advance the film after every shot, unless you're using multiple exposures for effect. If you're shooting the rectangular format, you'll have 16 exposures to a roll; with squares, 12 exposures.

Holgas have two ways of using the shutter. On the "N" setting of an N series Holga (or on any S series Holga), the spring shutter fires consistently at about 1/100 of a second. On the N series' "B" setting (for bulb), Holgas can be used to make long exposures. With this setting, the camera's shutter will stay open as long as you hold the shutter button down, closing only when you release it. Try this handheld to achieve blurry results. Or place your Holga onto a tripod for clearer images. Attaching a cable release further increases image sharpness by enabling the shutter to be held open with minimal camera movement. You can also try incorporating motion as an element in your long-exposure image. And remember, since the N-B switch is on the bottom of the camera, be sure to switch is back to N after using the bulb (B) setting.

UNLOADING

After shooting the last frame on a roll, it is time to rewind. Watching the counter window, wind the film-advance knob until you see the paper backing slide off to the right and out of sight. Then open the camera back (remembering everything about light leaks from Chapter 4), and remove the film, holding the paper so it doesn't unravel. To secure the film, peel the white tape off the roll and fold the paper tab under. Pull the paper taut, then lick and tightly seal the tape. Move the empty spool to the right side of your Holga, and you're ready to load your next roll.

HANDLING OF FILM

Unprocessed film is precious stuff. Your images have been created by the interaction of light with the chemicals in the film emulsion, but until they are processed, they are vulnerable to damage in a number of ways.

Squishing

120 film doesn't have a built-in protective shell like 35 mm film. Pressure on the rolled film can damage the emulsion and leave all sorts of strange marks on your negatives. Handle and store the film carefully. Tupperware-like containers are great, especially for travel, as are the 120 film canisters mentioned in Chapter 4.

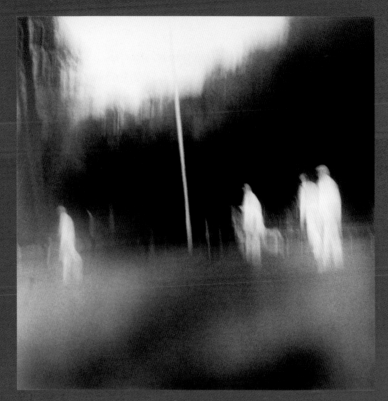

Bowlers, © Daniel Miller, 2000, from a project on lawn bowling. Holga camera modified with bulb setting, Tri-X film. Overexposing film with long exposures, or light leaks, can add interesting effects to images.

Light

Although 120 film is wrapped in a cocoon of paper, paper, after all, is still just paper. Intense, continuous light can filter through the paper and onto your film, creating very interesting patterns usually including the word "Kodak" superimposed on your images. To avoid this, load and unload the camera in subdued light and keep exposed film out of the sun, especially if the film isn't tightly wound. The 120 film canisters are great for light-tight storage, as is foil, or any dark bag.

Heat

All undeveloped film is vulnerable to heat. Try to be aware of environmental conditions, and don't leave film (that includes film when it is in your camera) in super-hot places. Professional film is even more vulnerable than amateur stock, since the film companies assume pros have more of a handle on these things. Since I travel a lot, I'd rather have the more flexible type (Tri-X 400 versus Tri-X 320 Professional). In general, a refrigerator is a good home for unused and unprocessed film (unexposed film will also last longer if kept cool), and, when you're on the road, it can't hurt to have a cooler along for the ride on hot or humid days. Cool and dry film is happy film.

X-rays

Just like airport security personnel think you can't be too careful about who or what you let on an airplane, the photographer can't be too careful about what kind of rays she lets pass through her unexposed or undeveloped film. Never, under any circumstances, put any unprocessed film in checked bags. Even the airlines admit that the x-rays used to scan checked bags will ruin film, so no question there these days; just don't do it. As for hand baggage, it's a little trickier to judge. Most

airports say their machines are safe for films under 800 ISO. Therefore, film 800 ISO or higher, or infrared or scientific film, can be hand-inspected. And while I think a pass or two under security x-rays probably won't do any damage to slower film, several passes probably will, which may be a problem if you're on a long trip with several flights. So, whenever possible, get film hand-inspected.

Now, even if your film qualifies for hand-checking, it doesn't mean security staff are going to make it easy for you. They want to see what you have. To save precious time in getting past security, always take new film out of boxes and store it in clear containers (Ziploc® bags or plastic boxes), and maybe they'll be kind and just look. More likely, they'll open it up and swipe a roll or two with a piece of fabric and run it through a machine. Once though, very cautious staff opened the foil packages of every roll of my film, which took quite a while. Film's expiration dates are printed on these foil wrappers, so keep a log of the dates if you must unwrap them. Also, use new plastic bags; used bags can carry residues that set off the machines, and a more thorough search. If you're planning to insist on hand-inspection, get to the airport early! You're asking the airport workers for a favor; don't annoy them by trying to rush them, and don't risk missing your flight.

Tracking Your Film

Finally, keep good track of your film. If your film needs special processing, write gently on the roll (with a marker, not a sharp ball-point) before placing it in your bag, so you can tell what's what when you get to the processing stage.

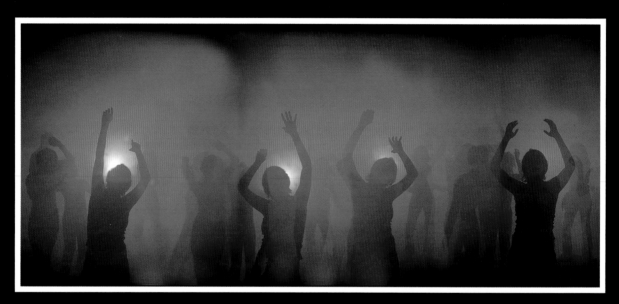

Dance floor, © Pauline St. Denis, 2002 for Sirius Network. This image makes use of color transparency film, strobe lighting, multiple exposures and panoramic format, all with a simple Holga.

chapter seven

Taking Your Holga Out to Play

WHAT TO SHOOT?

Whatever you want! Landscapes, people, still lifes, anything! You can use a Holga, Diana, Lomo, or other toy for your day-to-day snapshots, as a device for fine-art making or even to earn money. The sky's the limit, and the more intimately you know your tool of choice, and its idiosyncrasies, the better images you'll be able to make. In this chapter, we'll take a look at the ways the Holga sees the world, and how you can use your camera's functions (and malfunctions) to create exceptional images.

VIEWFINDER

The Holga's viewfinder isn't particularly accurate, especially when shooting the full square format. From my tests, you get around 30–40% more on the film than you see, which is very significant to know in judging your composition. I print my images using the Holga's entire negative (with a specially made negative carrier), so when framing my composition, I have to remember that a considerable

amount of the scene outside my viewfinder will also become part of the image. To make sure I don't end up with too much extra information around the edge of the negative, once I've framed my scene, I take a step or a few closer to my subject before clicking the shutter. Standard 6 cm × 6 cm negative carriers cut off a portion of a Holga's negative when printing. If you intend to print your

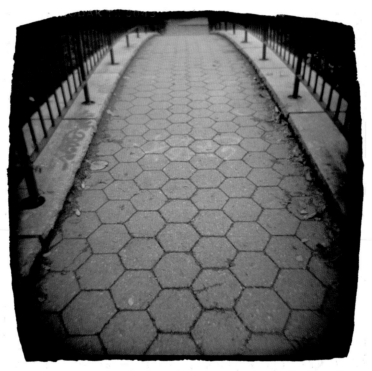

Boston Bridge, © Michelle Bates 1996. Holga camera full-frame image printed with cardboard negative carrier.

images with one of these, the viewfinder's view will be closer to the frame of the final image. You can also file out negative carriers to include different amounts of the negative. Experiment with the framing when you shoot, take notes to compare what you saw with what you got, then decide how you will present your images and frame accordingly.

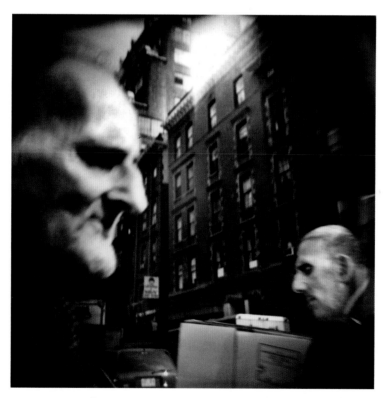

New York, 1999, © Michael Ackerman. Holga camera image.

VIGNETTING

Holgas have a fairly sharp lens (for plastic, anyway), but only in the center. When shooting the full 6 cm × 6 cm frame, your image will get darker and blurrier toward the corners. Pay attention to this effect in your images, and consider it when you shoot; it can be used to your advantage if you learn to love it.

MULTIPLE EXPOSURE AND PANORAMAS

Given the fact that Holgas and Dianas are completely manual cameras, you have far more control of your film winding than with other cameras. Sometimes the need to wind manually will cause you

Princeton University Football Team, © David Burnett/Contact Press Images, 2004. Holga camera diptych.

problems (I find the biggest cause of double exposures is giving the camera to someone else to photograph me, then forgetting to wind the film when I get it back), but it can be used for creative shooting as well. Double and multiple exposures are easy to create with these toys—simply don't advance the film!

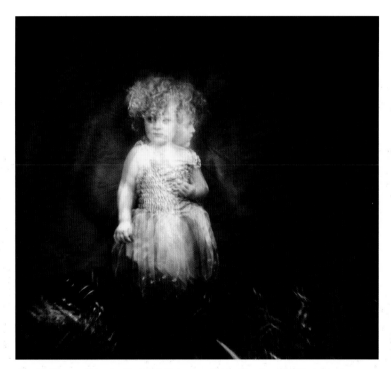

Ori the Amazing Two-headed Girl, © Laura Corley Burlton, 2005, from the series *Fairytales and Nightmares*. Holga 120S camera, 13″ × 13″ toned silver-gelatin print.

Panoramic images are created by winding the film only partway to the next frame, so that successive exposures overlap. One way to do this consistently is to use the frame numbers for 6 cm × 4.5 cm shooting (keep the pointer on the back at 16) without the 6 cm × 4.5 cm insert. Or try marking your winding knob to turn it a certain amount for each frame. When shooting a panorama of several frames, in order for them to appear in the correct order on the final negative, take the images starting on the left and move to the right. You'll need to be creative in the printing of these long negatives. Experiment with large format enlargers or digital printing (see Chapter 11). The possibilities for creating wide negatives are endless! In addition to the David Burnett image pictured here, look for panoramas by Susan Bowen and Pauline St. Denis throughout the book.

CLOSE UPS

Holgas can't focus on subjects that are very close to the lens. You can use the blurriness that results when shooting less than three feet away as part of your image, or you may want to try to make your images sharper. One way to do this is to use close-up filters in front of the lens. See the section on filters in Chapter 8 for details on using these filters to do macro photography. The Holga and Diana's viewfinders, already fairly inaccurate, lose even more relationship to what will be captured on the film when you shoot close up. This is called *parallax error,* and represents the difference between what the lens, at the center of the camera, sees, and what you see through the viewfinder. Be aware of this and move the camera slightly so the lens seems more directed at your subject. Make several exposures to make sure you get the framing right. Another way to extend a Holga's focusing range is to remove your lens and use a pinhole instead—shooting through a pinhole gives infinite focus (see Chapter 9).

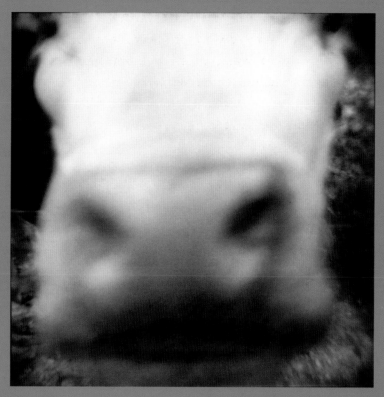

Cow's Face, © Nancy Rexroth, McArthur, Ohio, 1975. Diana camera vintage silver print, 4″ × 4″. Courtesy of Robert Mann Gallery.

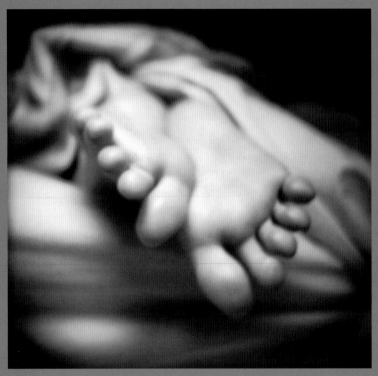

Feet, © Gordon Stettinius, 2005. Holga with close-up modification.

MOVEMENT

Holgas have a fairly fast shutter speed (~1/100 second). They can stop action, but sometimes still blur a very fast-moving subject. With the Holga's spring shutter, you can freeze a moment, or, while on the bulb setting, use long exposures to let blur and motion become part of your image. Panning is another technique to give a try, in which you rotate the camera to track a moving object during a long exposure. This will produce a relatively sharp subject against a blurred background. Using flash with the Holga is an excellent way to ensure crisply frozen subjects.

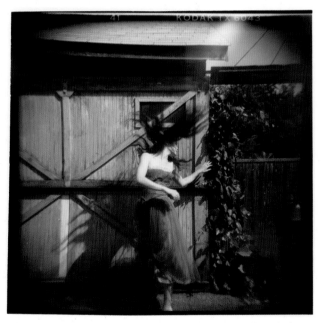

Untitled, © Kurt Smith, 1998. Holga camera photo as part of a series of images of dancers.

INTERIORS

Shooting a Holga in the low light of the indoors is tricky. To compensate, use fast films, which offer greater sensitivity to light, or use flash to add light to the scene. To make long exposures, use the bulb setting and plant your camera on a tripod. See Chapter 8 for more info on shooting with flash.

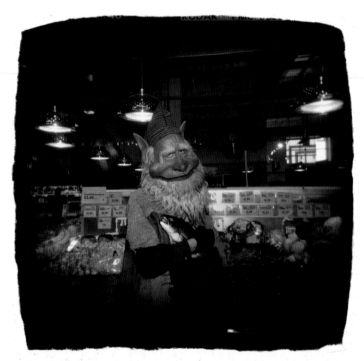

Clover Cuddles His Friend the Fish, © Michelle Bates, 1996. Dave McKay, incognito as Clover the Troll, goes shopping. Holga 120S camera image with Nikon flash attached via the hot shoe.

NIGHT

The issues of shooting at night are similar to shooting indoors, mainly, low light levels. With a flash, your plastic camera can make wonderful images at night; see Chapter 8 for more details. Even without a flash, anyone with a tripod, a bulb Holga or Diana, and some patience can spend the night out

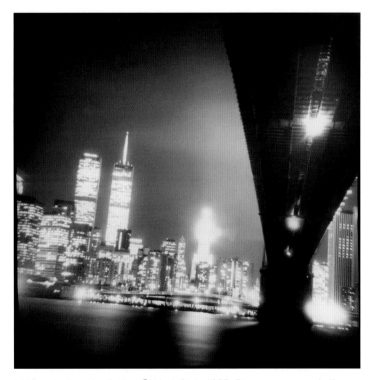

NYC under Brooklyn Bridge, © Mark Sink, 1997. Diana camera on bulb setting, Tri-X film at f/16 printed on Fortezo paper.

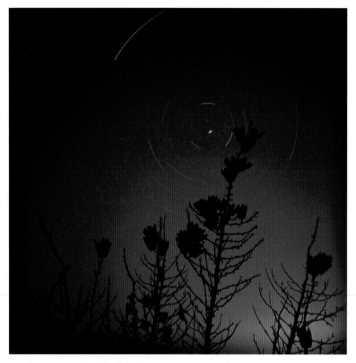

Night 382, © Becky Ramotowski, April 2, 2005. Holga camera with modified bulb setting, two-hour exposure on Agfa RSX II 100 transparency film.

and about and make gorgeous long-exposure night shots. Combining a long exposure with a flash is a way to allow you to capture a subject in the foreground (lit with the flash) and still have some detail in the background. When going out for night shooting, bring along a small flashlight to illuminate the frame numbers when advancing the film.

FLARE

One of the reasons people buy expensive lenses for their fancy cameras is that the lenses are coated in a way to reduce flare, that is, light streaks that result from shooting into a light source. The Holga, with its plastic "optical lens," doesn't have this coating, and so is highly susceptible to flare. You can try to minimize flare by not shooting into the sun or bright lights, or by taping a lens hood onto your

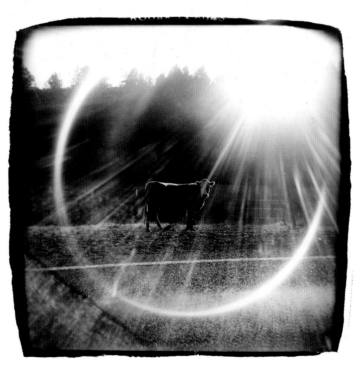

Holy Cow, © Michelle Bates 1996. Holga camera image made through a car window in eastern Washington on Tri-X film.

lens, or you can learn to embrace it. Flare is one of those effects that can add greatly to the look of an image. Since you don't look through the Holga's lens when composing, you can't see what it will end up looking like, so shoot with abandon, and see what you get. You may just learn to love flare and the unique images it creates!

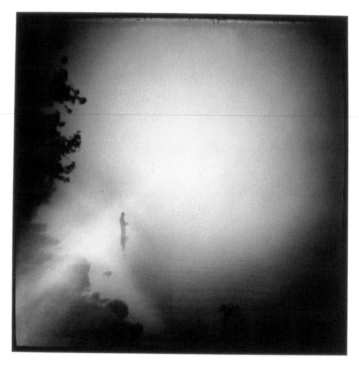

Rangeley Lake, Maine 1982, © Jonathan Bailey. Diana camera image on Tri-X film, gold-toned, silver-gelatin print.

COLOR

Holgas make wonderful color images! Experiment with film types, color and light: shoot at different times of day, in all weather conditions, and from varying directions in relation to your light source. Light can be beautiful and colors intense on overcast days, when the sun is low in the sky or when illuminating leaves and flowers from behind.

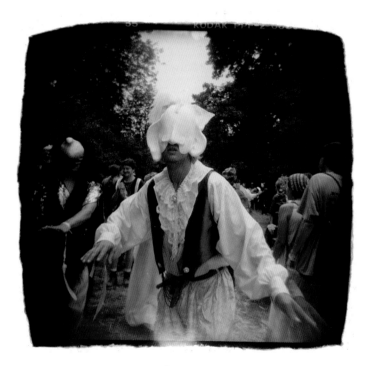

Intuit Parade, Oregon Country Fair, © Michelle Bates, 1997. Holga camera image on Kodak PPF 400 film (the precursor to Portra VC), with light leak.

The Holga CFN has a selection of color filters on the flash, or add your own colors by placing samples from lighting filter packs in front of the flash head. Color filters can also be used in front of all or part of the lens.

Light leaks take on a different character in color film. They are usually somewhere between yellow and bright red, making it much harder to get rid of them in the final image than with black-and-white film. The best you can do is hope they fit into your image!

PERSPECTIVE

Explore shooting from a variety of perspectives. Shoot up, squat down, hold the camera over your head, or spin around and click the shutter. Looking through the viewfinder is not required. You never know what you'll end up with!

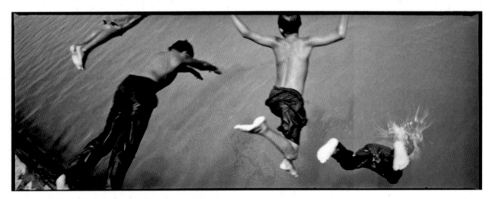

Los clavados, © Francisco Mata Rosas, 1998. From the *Litorales* series, taken with an Ansco Pix Panorama camera in Campeche, Mexico.

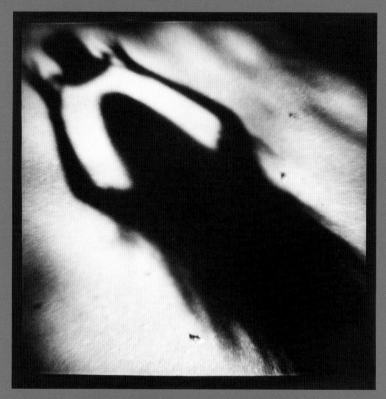

Kate's 14,600th Shadow, © Daniel Miller, 1999. Diana camera with Tri-X film, 7″ × 7″ silver-gelatin print.

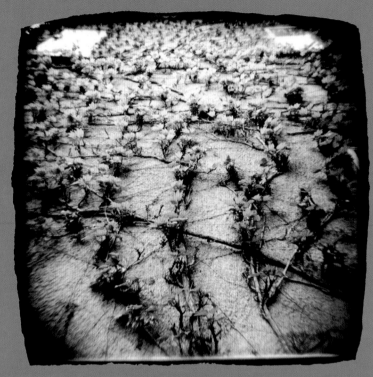

Ivy Wall 2, Cambridge, Massachusetts, © Michelle Bates, 2005. Holga camera on Tri-X film. Viewers often think this view is across the ground, until they notice the windows.

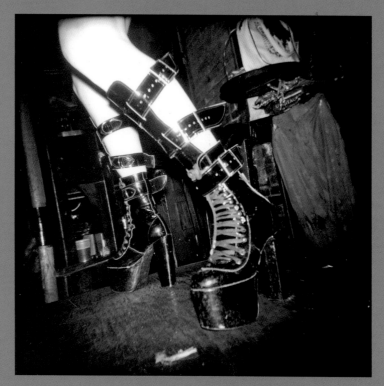

Dancer—Contempt, New York City, © Megan Green, 2002. Holga camera with flash on Tri-X film, pushed one stop.

GET EXTREME!

Holgas are not precious objects; they are cheap, don't have complex parts that can be damaged by exposure to the elements, and they float! So go out in the rain, wade in the ocean, even go snorkeling, and tote your Holga along to places you'd never dare bring a Hasselblad. For a little protection, drop your Holga into a Ziploc® bag; they're clear enough to shoot through, and flexible enough to turn with the film advance knob.

Holgas are perfect for other unfriendly environments as well, such as the dusty playa of Nevada's Black Rock Desert, where the Burning Man Festival is held each year. Playa dust will quickly cause costly damage to a "real" camera, and will start to eat a Holga as well, but a playafied Holga can easily be replaced. One problem to keep in mind though—your plastic partner can melt!

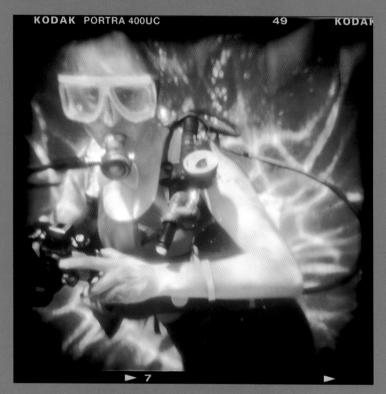

Robin Underwater, © Ted Orland. Holga takes a dunk underwater sealed in a Ziploc® plastic bag with Kodak Portra UC 400 color-negative film.

Bannerman, © Michelle Bates, 1999. An art installation, created by David Ti, from the Burning Man festival in the harsh Black Rock Desert. Holga image on Kodak PRN film (a precursor to the current Portra series films).

HAVE FUN!

The real joy of toy cameras is the freedom they give the photographer to play. Complicated instructions for custom functions go out the window, people are more curious than freaked out when you point a Holga at them, you're more likely to carry around a light, expendable camera, and worries about water and other damage are much lessened. When you know that your negatives are most likely going to be terrible, there is a freedom to shoot with abandon. Experiment, experiment, experiment! Find your vision, create your unique style, and have fun!

Surfers, Hawaii, © Ted Orland, 1991. Kodak T-Max 400 B&W film, gelatin-silver print hand colored with oil paints. Orland was in the ocean, and he and his Holga were swamped by the salt water.

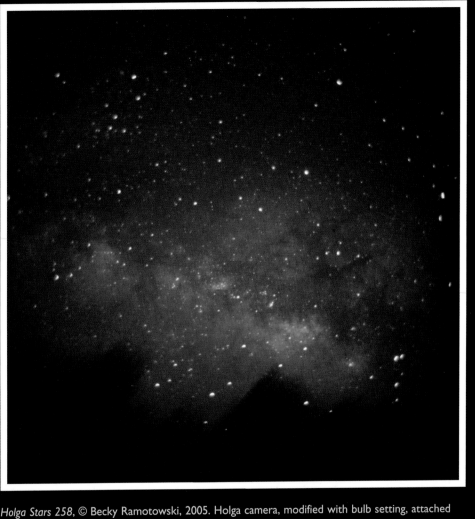

Holga Stars 258, © Becky Ramotowski, 2005. Holga camera, modified with bulb setting, attached to an astronomical mount that tracks the stars. Twenty-minute exposure on Fuji Provia 100 color-negative film.

chapter eight

Advanced Tips

TECHY TIPS

You've gotten film into your Holga and managed to get images without light leaks, but you want to take things further. Here are some photographic techniques to experiment with to expand the reach of what your toy is able to produce. Most of these are widely used on standard cameras as well, but plastic cameras have some special needs.

FLASH

Many plastic cameras are able to be used with flash, either built-in or external. Some Dianas (the Diana-F) have specially made flash units that plug into the top of the camera. These use old-style one-time-use flash bulbs, if you can still find them. The Action Sampler Flash has four flashes, that go off in sequence, one to a frame. The Holga line in particular has several options for using flash, which are detailed below.

Holga 120S with a hot-shoe and external programmable flash (*left*), Dories
(Diana clone) with flash unit that takes old-style flash bulbs (*center*), and
Holga CFN (*right*).

Flash on a Shoe

The range of scenes a Holga can capture can be greatly expanded with the addition of an external flash unit. The Holga 120S and 120N come with a hot-shoe, which is where the flash connects to the camera. The hot-shoe is wired with an electronic connection that triggers the flash when the shutter is released. Most flashes will work in the Holga's hot-shoe, but some will provide better results than others. Here are some tips to guide you.

First, in the world of flashes, bigger usually means more light output. This is significant when trying to light any broad space or subject, but leads to the inevitable struggle between convenience and price versus power. Consider your light needs and the importance of size and weight when deciding which flash to get.

Second, flash units have a variety of different levels of control. Many brand-name units will communicate automatically with a dedicated camera to find out its exposure settings, but our Holgas aren't that forthcoming. Instead, look for a flash unit that has manual controls, which allow you to enter the camera's exposure settings. When the flash knows what the camera is doing, it leads to better and more consistent exposures. With the Holga, these settings are an aperture of f/11, a lens focal length which is slightly wide angle, around 35 mm, and the film's ISO, which you determine. Combining this information with the sensor's reading of the amount of light bouncing back from the subject, the flash will adjust its output to create perfect exposures.

Some flashes also have extra features, like a swiveling head that allows the flash to be pointed at the ceiling, bouncing the light to provide broader and more diffuse coverage. Many types of modifiers can also be attached to the flash to alter the quality or color of the light output. And the Holga's own complementary flash unit, the Holgon, creates a stroboscopic effect by flashing multiple times, used when shooting a long exposure with the camera on bulb setting.

Since more expensive flash units can easily cost hundreds of dollars, getting one that can also be used with your other cameras is the most economical set-up; I use the flash from my Nikon kit on my Holga. If you want to stay on the cheap side of things, small, inexpensive flashes will synch with a Holga, and are certainly a usable, if less powerful, option.

One additional thing to note: Holgas eat flash batteries very quickly because the flash is fired twice for each frame, once when the shutter button is pressed down to click the exposure, and once when the button is released. Make sure to bring extras batteries along.

Built-in Flash

The Holga 120SF, 120FN, and 120CFN all have built-in flashes. Built-ins are convenient since they're always with you, but several issues make them problematic. The built-ins aren't very powerful, don't have a sensor or output controls, and are more likely to produce red-eye in color images, due to

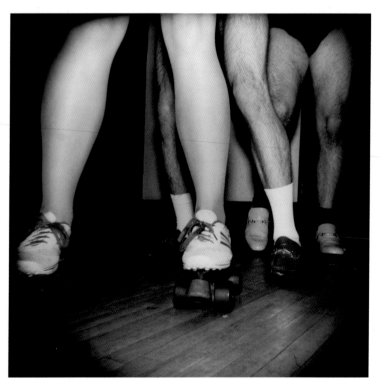

Roller Ball, © Gordon Stettinius, 1998. Holga with flash.

their close proximity to the lens. Also, the batteries that power the flash hide behind the film, so if they run out mid-roll, you can't replace them. Beware too, that the batteries' nesting place is not very secure, and keeping them in place in the camera is a challenge. Any of the camera inserts will do this, including a special version that won't cut into the image frame.

Within the Holga line there are different flash options. The 120SF and 120FN have a normal white flash, but the CFN has a few extra tricks up its sleeve. The flash has a dial that allows rotation of three different colored filters (red, yellow, blue) in front of the flash. While this does allow some on-the-fly creative possibilities, if you like colored flash, you can have more choices by keeping small pieces of color filters in your camera bag, and holding them or taping them in front of your flash.

Strobes

For full lighting control, any Holga can also be used with studio strobe lights. With hot-shoe Holga models, use a small device called a hot-shoe to PC cord adapter. The PC outlet lets you plug in a standard cord that triggers strobe lights. One thing to be careful about when using this type of setup is the Holga's "double-click." As mentioned in the section on flash, when taking a picture, the Holga's shutter clicks once on the way down (when the exposure is made) and once again on the way back up. This can cause technical problems when working with strobes, which will be triggered by both clicks. Since studio strobes take a few seconds to recycle, the second click will set them off again before they're ready, which can damage them and "blow the packs." If this happens, they may be fixable by hitting a hidden reset button, or the strobe may be put out of commission permanently. To avoid this, hold the shutter button down until all the strobes recycle (usually signaled by the re-illumination of the modeling lights), and then release the shutter button.

A Holga's built-in flash, or a flash sitting in the hot-shoe, can also be used to trigger strobes remotely. Yes, wireless technology even works with plastic cameras—imagine that! Most strobe lights have a built-in "slave" unit that responds instantaneously to a flash, setting the strobes off in time to light your exposure. Be careful—the "double-click" issue still occurs with this setup.

Using these setups, almost any type of lighting is possible. In some ways, simple cameras are ideal for using controlled lighting, since most of the adjustments in these situations are made with the lights. Simply set the light output so your meter reads f/11, and your Holga is ready to go! An enormous variety of types of studio strobes, modifiers, and backdrops are available. Consider getting a book or taking a class to guide you through the options and their use.

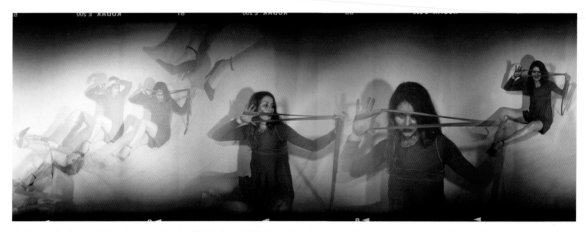

Cat's Cradle Blues, © Pauline St. Denis, 2003, for *125 Magazine*. Holga multiple exposure on chrome film, with strobe lights triggered via a hot-shoe adapter.

FILTERS

Filters open up a whole world of modifying your images from in front of the lens. Many books on using filters for both black–and-white and color photography cover the options in great detail, but here's a rundown of how to get a filter onto your Holga, and some varieties that you might want to consider.

Filter Holders

There is a custom-made filter holder available that creates a home on a Holga's lens for several sets of dedicated filters. The holder fits snugly over the Holga lens barrel, and the filters slide into it.

Holga filter sets. Standard circular filters may also be used by screwing a 46 mm step-up ring into the Holga's lens barrel.

Sets available are a group of colored filters (red, green, blue, orange), a group that have a clear spot in the middle and different colors of haze over the rest of the frame, and three beveled options. These three create a variety of multiple images within a single shot, and their angle can be changed by rotating the filter holder. Other gel filters can also be cut to fit into this convenient holder.

In addition to the dedicated Holga filters, there are many types of standard circular filters, widely used on all camera formats. These aren't immediately usable on Holgas, since they don't have threads in their lens barrels, like most lenses do. You can create some by using a step-up ring, which is made for bridging the size gap between larger filters and lenses with smaller threads. Get a ring that starts at 46mm, and screw it right into the soft plastic of the Holga's lens barrel. The larger sized threads will create a permanent place for attaching filters. These rings step up to many sizes; get one that matches the filter size of your other lenses, then share filters.

Filters come in all sorts of colors and can be used to create many different effects. Used with black-and-white film, tinted filters alter the tonalities of various elements of the image. For example, red filters intensify skies and contrast and are often used in B&W photography. Here are some other options:

Polarizing Filters

Polarizing filters are widely used in black-and-white and color photography to intensify colors and contrast, cut through haze, and decrease or eliminate glare and reflections. When used on an SLR, you can preview the degree of the effect by looking through the camera's viewfinder while turning the filter (which changes the direction of the polarization). However, since a toy camera's viewfinder doesn't present the view through the lens, polarizing filters are difficult to use. The best way to

compensate for this is to not screw the filter on at all. First, hold the filter in front of your eye and view the scene while looking directly through the filter, rotating it to get the desired effect. Then move the filter to the front of the lens, making sure not to change its angle as you are shooting the image. If you are not using a tripod, shooting while simultaneously holding the filter in position can be a bit tricky. These filters block a large amount of light (up to two stops), so remember, when using them in low-light conditions, that your exposure will be decreased. Both linear and circular (required for use with autofocus lenses) polarizing filters are appropriate for use with plastic cameras.

Neutral Density Filters

Neutral density (ND) filters can be useful when shooting in very bright conditions. Since you can't change Holga's aperture or shutter speed to decrease the amount of light entering the lens, generally film speed provides your only control over exposure in bright light. ND filters block light without affecting color or tonal balance, thus giving you an extra element of control over exposure. They come in various densities; the most useful ones for a Holga are the full-stop filters, which block a significant amount of light. A .3 ND filter cuts one stop of light, .6 cuts two stops, and so on. Keep one, or a set, handy in your camera bag if you have trouble with over-exposed negatives. Your polarizing filter can also be used to cut exposure, with or without taking advantage of its other effects.

Graduated and Split Filters

Graduated filters impart an effect onto only a certain section of the image. They are usually split in half; one part clear, and the other either colored or darkened. One of the most popular is a half neutral density, which can block some light from a bright sky, while leaving detail in a darker

foreground, decreasing the overall contrast of the image and making printing much easier. Graduated filters also come in a variety of colors, which can be used for more or less dramatic effect depending on their hue and the film you are using. The issue of placement comes up with these filters as well, since you can't see through the lens to achieve precise alignment of the edge of the filtration with the horizon, but with experimentation, good results are possible.

Macro Filters

The Holga's lens isn't made for focusing on close-up objects. The one-head setting will allow you to photograph subjects about four feet away, but there's a whole world closer than that. By using macro filters, a type of magnifying lens made for this purpose, you can take the Holga down to the ground or up close to a face.

Once again, since you can't see through the lens of the Holga to know the effect close-up filters are having on the focus, you'll need to develop a system to get the results you want. The filters come in different strengths of +1, +2, +3 and up to +10, and can be bought in sets. The down-and-dirty way to get your shot in focus is to shoot a composition several times, using each filter, and hope that one comes out right. This works for the occasional shot, but if you plan to do close-up shooting on a regular basis, you can save lots of film by testing your filters in advance.

Here's the drill: make yourself a setup that includes a small object, piece of text, or resolution chart; a Holga with a bulb setting; a tape measure; and a loupe (or magnifying glass). You'll also need

either a piece of ground glass (like on the back of a view camera) or any kind of translucent paper, like waxed or tracing paper. Take the back off your Holga, and, if possible, put the camera on a tripod. Place one of the camera inserts into the Holga, (even if you don't shoot with one); this will make sure you're testing focus at the film plane. Then tape the ground glass or paper across the camera insert. Move the Holga's focus ring to the one-person setting, click open the Holga's shutter and lock the shutter button down with a cable release, or tape it down with gaffer's tape. Place the loupe or magnifier up against the glass or paper, and, moving the camera towards your object, text or resolution chart, look through the loupe for the subject to come into focus. Mark down the distance. Then, one by one, set your test filters in front of the lens (either screwed into your step-up ring or taped on), and repeat the measurements. If you want to get even closer, stack the filters (+1 and +2, +1 and +3, +2 and +3) and test these combinations as well. Keep your focus distance chart with your filters and have the tape measure on hand (make a dedicated bag for the whole kit), and you'll be in focus every time!

Following are the results of my tests.

	+1 Filter	+2 Filter	+3 Filter	No Filter (on the close focus setting)
Distance in focus, from front of lens	20″–24″	13″–15″	9½″–11½″	4′–7′

Maine Coast Boulder, © Michelle Bates, 2005. This image was made with a Holga and a +1 Hoya macro filter held in front of the lens. Several exposures were made with the different filters to get the best focus.

Add-on Lenses

Many types of add-on lenses are made for digital and video cameras. Camcorder lenses have a 46 mm thread, perfect for screwing into the Holga's lens barrel. Try different wide angle and telephoto options to see what works for you.

POLAROID HOLGA

As mentioned in our review of film types, Polaroid, until recently, manufactured a back that slides right onto the back of any model Holga (aren't you Diana users jealous?). Using Polaroid materials completely alters the photographer's shooting experience, giving, for the first time, immediate results with a Holga flair. You'll have prints to give to your subjects or to scan, and can have a negative to take home and print as well. While this Polaroid back, which has been variously called a Holgaroid and PolaHolga, is no longer made, used models should remain available on the internet.

The Polaroid back completely covers the Holga's viewfinder, so composition is determined either by guessing or using Freestyle's external (and approximate) viewfinder. The back will not connect very tightly, relying as it does on the Holga's flimsy clips, so tape it on and be gentle. And since the film plane will be at a different distance from the lens than with roll film, the Polaroid back comes with a diopter corrective lens that must be used over the lens to get in-focus images.

The Polaroid Holga back takes a special series of film, called Type 80 series. There are only a few types in this series, and, with the discontinuation of manufacture of the back, film availability is sure to suffer. The options follow (although they may not be currently available). The color films are an ISO 80 punchy color (Type 88) and ISO 100 natural color (Type 89). The black-and-white series consists of an ISO 100 (Type 84), an ISO 3000 (Type 87), and, my favorite, an ISO 80 positive/negative film (Type 85). In addition to producing an immediate print, this film gives you a glorious rich $3'' \times 3''$ negative to print from later.

When shooting Polaroid film with a Holga, it's a challenge to get good prints. With a standard Holga's one shutter speed and aperture there is only one exposure setting. Since the Polaroid film's result is the final print, if the light isn't right for those exact settings, you won't get a satisfactory image (similar to transparency film). There are several ways to increase your chances of getting good results:

1. Use a programmable flash, as detailed earlier in the chapter.

Clouds photographed with a full-frame Polaroid Holga back onto Type 85
positive/negative film. The negative was scanned and inverted in Adobe
Photoshop. Michelle Bates, © 2004.

2. Use a Holga on bulb setting. With this option, you may want to use a light meter to determine the best exposure.
3. Use the Type 85 positive/negative film.

Polaroid Type 85 film, recently discontinued, was the most useful for Holga users. This film produces both a print and a negative. It's difficult to get both a good quality print and negative on the same shot, but with a well-exposed negative, a world of information is available for later printing, in fact, ten times more information than is in the Polaroid print! Therefore, if you can get any Type 85, it's better to expose for the negative.

Type 85 negatives are slightly larger than a normal Holga negative, and have a quality all their own. These negatives (like other format Polaroid pos/neg films), need to be cleared after exposure. This is done by bathing them in a bath of sodium sulfite, so pack along a sealable container with this fixing solution, or water to store them for later fixing. In order for the prints from Type 85 images to last, they must be coated with the included swiper. This process is smelly and the coating takes quite a while to dry. And, as with all pull-apart Polaroid film, bring a garbage bag for all the paper backing gunk. All of this makes for some very complicated shooting in the field, but the images are unique and have a special quality. Let's hope the film is re-introduced.

INFRARED FILM

Infrared (IR) film has sensitivity to light beyond the visible spectrum. It detects wavelengths into the infrared spectrum, from 700–900 nanometers (nm), which can't be seen with the naked eye. When used with filters to block some of the visible light, IR films create images that alter normal tonal values and have a special luminosity to them. In these images, skin and foliage are represented as almost

white, making them seem to glow, while skies and water go dark. Many wonderful books and web sites describe IR photography. And as for the question photographers ask: Can IR film be used in a plastic-bodied camera? The answer is yes!

Only two types of IR film are currently produced in 120 format (this is always changing, so do your homework): Macophat IR820c (ISO 100) and Rollei Infrared (ISO 400). I found the Rollei film to be the sharper of the two, and its extra speed was very significant, especially since the filters block a substantial fair amount of light. Aside from the Maco and Rollei films, there are also a few other types of infrared films available in 35 mm that can be used in the Holga, as described in Chapter 9. The 120 films (unlike some more sensitive IR films) can be handled in subdued light, and my tests found that the plastic body and red window didn't create light leaks on the film. But in super sunny environments (which are the best for shooting with these films), bring along a changing bag for loading and unloading the film or for fixing it if you have rolling problems; they are more sensitive to extraneous light than other films.

Without filters, IR film can be used more or less as normal film. To get the IR effect, filters must be used over the lens. The standard filter is a #25 red, which blocks about 2-stops of visible light, allowing the balance to lean more toward the IR effect; its darker cousin, the #29 deep red, intensifies the IR effect even more. Several totally opaque IR filters, such as the #87 and #89 can be used as well; these further exaggerate the effect, but need much longer exposures. You can't see through these filters at all, which makes the Holga the perfect camera to use them with, since you don't look through the lens to compose anyway. With all of these filters, the problems of exposure inherent to the Holga are increased by the reduction of light reaching the film. Use a Holga on the bulb setting and with a tripod, adjust your variables, and keep good notes.

Another fun trick with infrared film is to put a piece of #87 opaque filter over a flash, and use the IR light that gets through to light your shots. With this so called "dark flash," the illumination is invisible, making it great for interior shots where a normal flash would be distracting.

Holga camera with Rollei IR 400 film. Taken on a bright, hot day at Seattle's Greenlake, with a 25 red filter attached to the lens via step-up rings. Michelle Bates, © 2006.

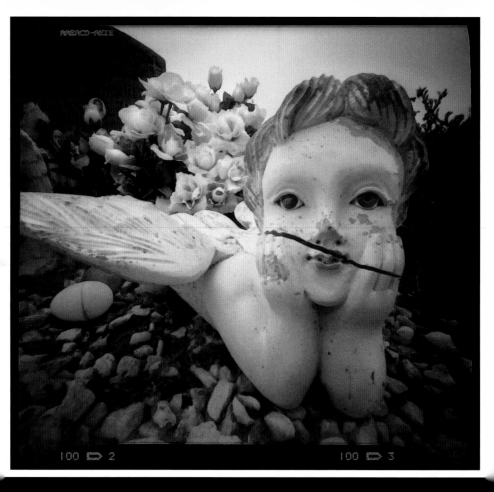

Damaged Angel, © Ted Orland, 2001. Pinholga (Holga camera modified with pinhole) photograph of six-inch high statue taken from a distance of six inches, on color negative film; edges modified with dry

chapter nine

Holga Camera Modifications

Plastic cameras are cheap, and usually quite uncomplicated. This makes them easy to disassemble, mess around with, and revamp to your own specifications. Here are a few examples of modifications you can do with your Holga. There are lots of other ideas out there on the web for the Holga or Diana, or get out your tool kit and create your own customized photographic tool!

Simple Holga Modifications

Tone Down the Interior

In addition to the basic taping discussed in Chapter 4, some people think that flocking, or painting the interior of their Holga with flat or ultra-flat black paint, helps keep light leaks to a minimum. Flocking is good to know about, although I've never had any issues that I attribute to light bouncing around in the Holga's shiny interior.

Bulb Setting

If you have an older Holga 120S, it's possible to alter the camera to have a bulb, or even "T" (time) setting. Since all Holgas in the 120N series now have a bulb setting built in, I won't include instructions for altering the older model, but they're easily found on the World Wide Web.

Use 35mm Film

Holgas are meant to take 6-cm tall 120 film, but they can also use 35 mm film, creating panoramic images that spread all the way to the edges of the film and over the sprocket holes, which can become an element in the image. It's easy to convert your Holga to 35 mm.

Take a 35 mm cartridge, and center it in the left side of the Holga. Cut out pieces of foam to go above and below the cartridge to keep it snugly in place (see figure). Once the cartridge is secure, pull out just enough film to reach over to the other side, and insert the leader into the take-up spool. Tape the film leader onto the reel to help keep the film in place. Wind the film advance knob just enough to make sure the film is centered and will stay on, and close the camera back.

It's very important to remember when using 35 mm film to keep the back counter window securely covered at all times. 35 mm film doesn't have a paper backing, like 120 film does, so opening the window covering *will* expose the film to light (filtered through the red window) and ruin it.

Winding the film without having numbers from 120 film's paper backing to guide you is somewhat of a guessing game, so you'll need to keep track of frames with the winding knob. Use 1½ revolutions of the knob as a starting point to wind one frame, or count the number of clicks of the knob, (which is usually around 34 clicks per frame). Since the film at the start of the roll is unusable (having been exposed to light during loading), make sure to wind the film on far enough to get fresh film into the camera body.

When you're done with your roll, place the camera in a changing bag (or take it to a light-tight room), pull out the cartridge and take-up reel, and, in the dark, gently turn the stem on the film cartridge counter-clockwise to rewind the film into the cartridge.

If you're really handy, it's possible to make a rewinding lever by poking a hole in the bottom left of the Holga and inserting a screwdriver into the canister stem.

Commercial converter kits that make your camera 35 mm-ready are also available.

Go panoramic with 35 mm film in your Holga!

Mermaid, © Gordon Stettinius, 2005. Holga camera with 35 mm film.

Advanced Holga Modifications

Two Real Apertures!

If you've been carefully checking your exposures (and really, who does with a Holga?), you'll realize that the aperture switch is useless. The arm that swings out when you flip the switch to sunny has a hole that's larger than the opening to the lens, so in both settings, the aperture is the same. And, contrary to what the switch label would have you believe, the flash works on both settings. The only thing the switch *can* do is ruin images if left in-between the two settings. But there is a fix! In fact, two: you can give your Holga a smaller aperture or a larger one. Or both!

To get at the guts of your Holga, remove the screws inside the camera (circled in the figure) with a size zero screwdriver. Take the front of the camera off, being careful to keep the wires intact if you intend to keep using the hot-shoe or built-in flash. Next, remove the two smaller screws that hold the shutter mechanism onto the front part of the camera (see figure on next page). Pull the shutter mechanism out, and you'll find the aperture arm.

There are two modifications you can do at this point. The first is to make the maximum aperture larger by removing the small black ring set behind the lens (see figure on page 177). This makes the cloudy setting into a wider aperture. Carefully lift out the aperture arm, then use a small screwdriver to gently pry this ring out.

Take out these two teeny screws to remove the front part of your Holga. Be careful not to lose the screws!

The second is to make the hole on the aperture arm smaller. Find a piece of cardboard, or other material that's the same thickness as (or thinner than) the aperture arm. Cut a piece the same size as the aperture opening, tape it in place with scotch or mylar tape (anything thicker will interfere with the arm's movement—do not use gaffer's tape here), and cut out a round opening for the aperture. Another option is to cover the entire opening with silver mylar tape (the kind used for masking slides) on both sides, then use a small punch to make your aperture hole. For good measure, color the tape black to minimize reflectivity. When creating your smaller aperture setting, be aware that below a certain diameter, your images will start vignetting, to the point where they can become circular. If this happens, you can either keep the circular look, or make the hole larger until you get whole images again.

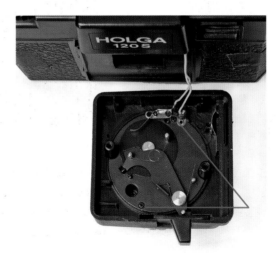

Next remove these two (even teenier) screws to remove the shutter assembly and access the aperture arm.

Put it all back together, and you'll have a Holga with the cloudy setting aperture larger, and one sunny aperture smaller than normal, so carry it with a standard model, and you'll have a whole selection of exposures to choose from!

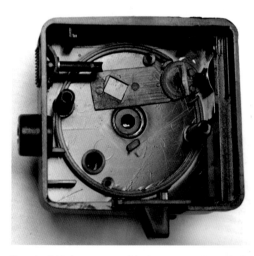

Standard Holgas come with the aperture arm hole larger than the main aperture. This is a Holga 120N with bulb setting and tripod port.

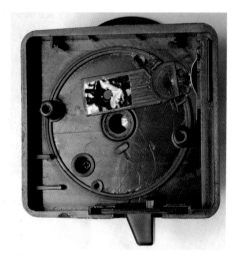

A Holga 120S, with the modifications described in the text. The camera aperture is larger, and the arm's aperture is smaller. That's silver mylar slide-masking tape, colored with a black marker.

Built-in Filter Changer

While you're in the guts of your Holga, another neat alteration is to tape a piece of colored filter over the aperture arm's opening. This gives you an instant on-off filter switch! Red filter is useful for black-and-white shooting. Or, if you have problems with over-exposed negatives, attach a piece of neutral density filter to the arm to create a simple switch for cutting the amount of light reaching your film.

PinHolga

If a plastic lens isn't low quality enough for you, you can shoot without a lens at all. You can easily convert your Holga into a pinhole camera, which is nicknamed a PinHolga. The first step towards creating your PinHolga is to take off the front of the camera. To do this, remove the camera back, and unscrew the two interior screws you'll see inside the body (see figure in previous section). Since you won't be needing your flash any more, disconnect the wires. Over the Holga's new front opening, install your pinhole with light-tight tape. The pinhole itself should be out of thin foil or metal (disposable aluminum pie pans are perfect), but it should be mounted within a sturdier material. Use a lens cap or other piece of opaque material to cover the lens when not shooting, and remove it to make a photograph. Finally, a use for the lens cap!

Pinholes can also be mounted to the front of the lens mount. In this set-up, the lens is removed, a pinhole mounted to the front of the lens barrel, and the built-in shutter can still be used for making exposures (better, obviously, on a Holga with a bulb setting).

There are many resources to help you make the appropriate pinhole sizes, the premier ones being Eric Renner's book, *Pinhole Photography: Rediscovering a Historic Technique* (Focal Press, 2004), and website, www.pinholeresource.com. Shooting with a pinhole camera takes time and patience. Shutter speeds are slow and the camera needs to be mounted on a tripod. Given that pinhole cameras are always in focus, from up close to infinity, this is one way to get your Holga to focus close up!

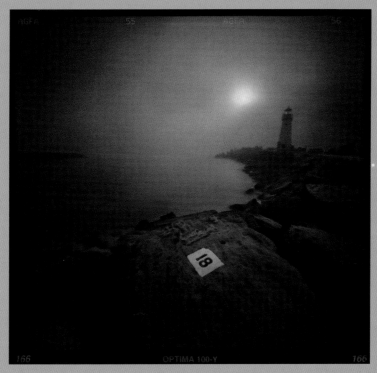

Lighthouse #18, © Ted Orland, 2003. Holga camera modified with pinhole, on Agfa Optima 100 color-negative film. Twenty-second exposure in lifting fog.

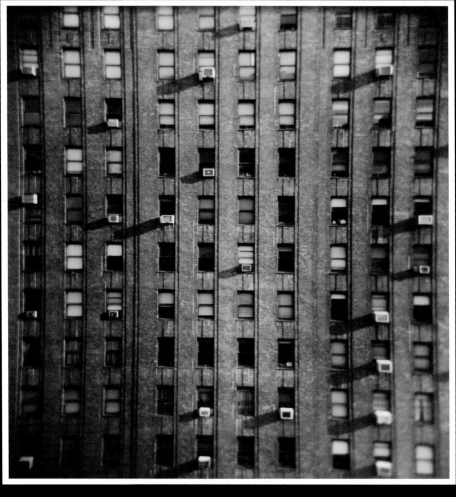

West End Avenue Building, New York City, © Harvey Stein, 1999. Holga camera, B&W negative film,

chapter ten

Film Processing

NOW WHAT?

You've got the film into the Holga, snapped a few photos, and taken the exposed film out. Now what?

The Diana and the Holga, and most of the cameras in this book, still live in the world of film. Even if the rest of your image-making process is going to be digital (see all the final image options in the chart at the end of this chapter, and in Chapter 11), it's important to give attention to your negatives. Your choice of film and method of processing have a great impact on the success of your shooting, and play critical roles in achieving your artistic vision.

PROCESSING THE FILM
Lab

There are a variety of choices available for getting your film developed. Black-and-white film can be processed at home by hand, or at a lab, while color negative (C-41), black-and-white C-41, and

transparency films (E-6) require lab processing. As mentioned in Chapter 5, if local black-and-white processing isn't available, Ilford XP2 and Kodak BW400CN monochromatic films are handy, as they are processed in standard lab C-41 chemicals. Not all labs are set up to process 120 film, so call around first. If 120 services aren't available locally, there are mail-order options.

Hand Processing

Processing your black-and-white film yourself gives you the most control over your negatives, through a wide selection of film stocks and chemistry. This can be particularly useful with plastic cameras, which offer minimal exposure controls, and rarely make perfect negatives.

Contrary to popular belief, you can process film at home without having a full darkroom set-up; in fact, any sink will do. The only time you need darkness is when rolling the film onto the reels, and this can be done in a light-tight closet or a changing bag (I have two of these: a small one for my camera bag, and a larger one to fit processing tanks and reels). Rental facilities are available in some areas that provide processing facilities as well.

The basic equipment needed to process film is minimal. You'll need a processing tank and reels, a set of bottles for chemistry, and some way to hang your film to dry. The tanks and reels come in plastic or metal, in a variety of sizes: reels that fit 35 mm or 120 film, and tanks in all sizes, from the smallest that holds one 35 mm reel up to the largest that can hold eight 35 mm or four 120 reels. The required chemicals are a developer, stop bath, fixer, and, ideally, a fixer remover and rinsing solution. For washing, special washers are made, but film can be washed effectively in the tanks as well. And for drying, the most elaborate set-ups are drying cabinets with heating and air filtration systems, but hanging film over a tub in a relatively dust-free bathroom is a good alternative. Altogether, it is cheap and easy to pull together a home processing set-up.

The main choice in processing is the type of developer you use, which, in conjunction with your film choice, allows quite a variation in the final look of your images. A good starting combination for use with plastic cameras is Tri-X 400 film and HC-110 developer, which together give a wide degree of latitude (the ability to represent a wide variety of tones). Specialized developers result in negatives that have finer grain, or higher or lower contrast, and some are necessary to develop certain films.

Guidelines for processing film, and information on film and developer combinations, are readily available online, in photography books, and in classes and workshops. Following is an overview of some more advanced techniques for getting the most from plastic camera negatives.

Changing Development Times

Push-processing is a useful technique for compensating for rolls of film that were under-exposed in the camera. Under-exposure is common with plastic cameras, with their relatively fast shutter speeds and small apertures. Film is pushed by processing it in the developer for a longer amount of time than normal development. Extending the development time allows more of the latent image on the film to develop, and also increases contrast.

Pull-processing, or decreasing development time, can help save over-exposed negatives made on very bright days. This complementary process cuts the amount of time the latent image is allowed to develop, making negatives less dense and decreasing contrast.

Both of these processes can be used to compensate for less-than-ideal shooting conditions, as well as mistakes. Changing the development times can also be used as an intentional technique for shaping the final look of your images. Tables that detail development times for both push- and pull-processing are often printed in film packaging, and more detailed charts are usually online at the manufacturers' websites.

If you realize at the time of shooting that your roll of film would benefit from one of these processes, mark the roll clearly with a soft marker before you stash it in your bag. The standard notation for push-processing is "+1" for one stop extra development, "+2" for two stops, etc. For pull-processing, you can simply note "−1", "−2", and so on. You can push or pull process at home, or ask your lab to do it to black-and-white, color negative or transparency film. If your roll is partially under-exposed and partially over-exposed, and push- or pull-processing isn't a viable option, there are a few other things that may help save your negatives.

Negative Intensification

Sometimes the perfect image will be recorded on a less-than-perfect negative. If the frame you love is underexposed (or too thin to make a good print), one possible save is negative intensification. Intensifiers include silver, chromium, and selenium, any of which can be used to build up the metal content, and hence the density, of the silver negative. Intensifiers can be applied to entire negatives or selected areas, but the results are permanent, so you will want to practice first.

Be aware that these formulations are quite toxic, and must be used with care and good ventilation. They can be purchased from the Photographers' Formulary or at specialty photo stores.

Negative Reduction

Negatives that are overexposed, or too dense, can also sometimes be improved by a process called negative reduction. Products that do this include Kodak's Farmer's Reducer and Photographers' Formulary's line of film reducers. This process, like intensification, can be used to modify entire or partial areas of negatives.

Troubleshooting Your Negatives

Plastic cameras are not high-tech. They don't think for you, and they don't try to stop you from doing something wrong. Hence, shooting with a Holga, Diana, or other toy will inevitably give you some uneven, or just plain bad, negatives. I usually need to dodge and burn (see boxed text in Chapter 11) my contact sheets just to see all the frames; what would Ansel think?

In photography, like anything, you're more likely to learn from your mistakes if you know what they are. Keep notes of shooting conditions and your techniques, then compare them to your negatives, and you'll be better prepared the next time out. Here are some common issues:

Underexposed (thin, or light) negatives: This is very common in the toys, and results from an insufficient amount of light hitting the negative. Try using faster film, flash, multiple exposures, or a bulb setting. Using a handheld light meter can help you determine if the light is sufficient for shooting.

Overexposed (dense, or dark) negatives: If your negatives are consistently too dark, use slower film or filters (neutral density or polarizing) to cut the amount of light reaching the film. Also, be aware of the fact that as Holgas age, the springs that trigger the shutter may get weak or slow, leading to longer or inconsistent exposures.

Light leaks: See Chapter 4 for a detailed discussion of the light leaks inherent to Holgas and how to fix them. Here are some common ones for reference:

- A cone of white coming down into the image from the upper right of the frame: This is caused by light leaking through the two holes above the interior of the camera. Cover them up.
- Streaks of light coming in from the edges of the film, especially towards the end of the roll: This is caused by light leaking through the edges of a roll that isn't wound on tight, after removing it from the camera.

- Splotches of light in the center of an image, sometimes with text imprinted: This results from excess light coming through the red counter window. Keep it covered when not in use, and uncover only in subdued light.

Dianas, especially, need to be fairly well covered with tape along the camera seams to keep out the light.

Blank frames: Did you leave the lens cap on? I said all the way back in Chapter 4 to throw it away, remember? Also, very low light situations can fail to expose the film at all. Or your shutter may be broken. And, if your processed film has no images and no text along its edges, the problem occurred in the processing stage. Check your chemistry.

Overlapping frames: Film wasn't wound properly between frames. Look at the numbers through the back window when winding. Sometimes if a Holga isn't used for a while, the film will loosen, also causing overlap. And make sure the window arrow is pointing at the 12 if you're shooting square format.

Vignetting: So your corners are dark? Well, they're supposed to be. Don't like it? Get a Hasselblad.

CUTTING AND STORING NEGATIVES

Toy camera negatives can often have peculiarities that make filing in negative sleeves or sheets a challenge. In a Holga or Diana, film is manually wound from one frame to the next with no prompting or guidance from the camera. The winding distance between frames is judged by reading frame numbers through the red window in the camera back. But sometimes the film winds loosely, or the photographer is in a hurry and doesn't look at the numbers, and the images don't end up being evenly spaced along the length of the film. Or, a photographer may intentionally shoot panoramas, combining several frames to make one long image. In these cases, someone trying to cut the film into standard sized strips may ruin good images by cutting apart adjacent frames. To ensure this doesn't happen, always ask that your film not be cut when bringing it to a lab. Then pay careful attention when getting ready to cut them yourself.

I keep two types of negatives pages always on hand: ones that hold four strips of three Holga (6 cm \times 6 cm) frames each, and ones for three strips of four frames (see figure). For each processed roll, I count out my images, see where the largest gaps are between frames, figure out which pages would best fit the cut strips, and snip accordingly. Sometimes I'll need to split a roll between two negative sleeves to fit different-sized strips. If I need to have the lab make contact sheets, I try to stop by the lab between the processing and contact printing to cut the negatives myself.

Negatives from multi-lens or panoramic 35 mm cameras can also cause confusion for a lab. Make sure you warn them of any strange image details in advance, and make your precise wishes known.

Finally, to prevent discoloration and degradation, always use high-quality negative pages and keep them in archival storage folios or boxes.

Black-and-white and color negatives from the Fremont Summer Solstice Parade in Seattle show the different types of storage sheets, the range of frame spacing, and some edge light leaks.

An Overview of Options from Film to Final Product

Creating a final image from a plastic camera negative involves many choices; these include how to develop the film, and from there, how to review the images, and what the final output will be. Here is an overview of options for all the types of film you can run through your toy. See Chapter 11 for details on how to view your images or make prints once your negatives are dry.

Film Type	Processing Options	Digital Input	Print and Output Options
Black-and-white	• Home processing • Photo lab	• Negative scanning • Print scanning	• Home or rental black-and-white darkroom printing • Digital prints • Web, digital media • Lab prints
Black-and-white C-41 (Ilford XP2 or Kodak BW400CN)	• Color photo lab	• Negative scanning • Print scanning	• Black-and-white darkroom printing • Color darkroom • Lab prints • Web, digital media, and prints
Color (C-41)	• Color photo lab	• Negative scanning • Print scanning	• Digital prints • Web, digital media • Lab prints • Home or rental darkroom printing
Transparency (E-6)	• E-6 photo lab	• Transparency scanning	• Digital prints • Web, digital media • Lab prints • Home Ilfochrome printing

Note: Processing was covered here in Chapter 10, and printing is covered in Chapter 11.

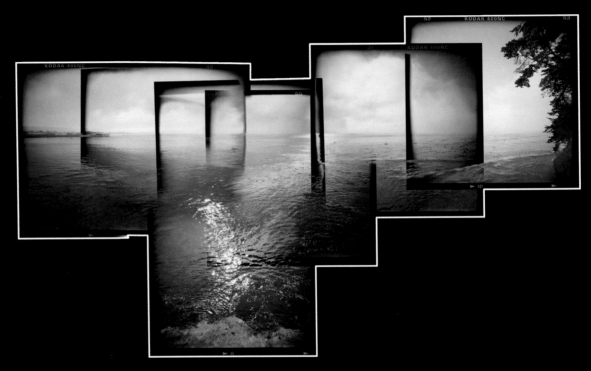

The Ocean in Summer, © Ted Orland, 2002. Holga camera with Kodak Portra UC color-negative film. Orland combines several negatives in Adobe Photoshop®, manipulating the layers with masking to create dramatic montages, which are printed digitally up to 24″ × 50″. These images were made while walking his dog near his home in Santa Cruz, California.

chapter eleven

The Final Image: Prints and Pixels

Once you've finished processing your negatives, there are several different paths available to

produce your finished images. We're here in this book because we love the simplicity, afford-

ability, unpredictability, soft imagery, or other aspects of making images with plastic and toy

cameras. But we must tackle some kind of complex technique to create the final piece of

work, whether it be a fiber-based silver print, a virtual image, or a digital print. The options

we have to select from today are representative of the choices all photographers have to

make, with digital technology becoming more dominant every year. I present here

information about both darkroom and digital options, and, as usual, I encourage you to test

them out to help you decide what works best for you. Taking workshops or classes, or work-

ing in a rental facility, are excellent ways to try different techniques before you invest in your

own equipment.

Black-and-white darkroom technology has stayed fairly consistent over many decades. It's possible to use the same equipment and chemistry formulations our grandparents did, with spectacular and long-lasting results. Even with the consistency of the basic technical tools and skills needed, fine-art darkroom printing is not easy to master, and people spend decades refining their techniques. But the stability of the form allows photographers to deepen their proficiency over time within this classic art form.

On the other hand, digital equipment, software, and the skills needed to master them, change considerably each year. There are some people who manage to keep up with the costs and skills, while many others struggle to keep up with the minimum needed to function within the changing landscape. To take advantage of its many conveniences, I use the computer constantly—for scanning, emailing, posting, updating my web site, and printing digitally—and shoot with digital as well. But all this expediency comes with a long and continuous learning curve, and taking time to master the computer takes time away from expanding my skills in the darkroom, which I still use to make exhibition prints. And I'm constantly meaning to read a book or take a class to get better at Adobe Photoshop®, which itself keeps changing with each new version.

While many people will argue that the darkroom is dead, there is still space to explore in the safelight, and setting up a traditional darkroom costs less money than a digital setup. In fact,

darkroom equipment can be acquired for very little money these days, as many people move to digital. So, I hereby give permission to plastic camera shooters everywhere to continue sloshing around in chemicals, and apologize to the contributors to this book who I pestered into sending me digital scans!

Here is a quick rundown of your options at this point for reviewing and printing your images:

REVIEWING YOUR IMAGES

Before you get into making prints, you'll want to review your images to decide which you like best and select those you want to put more time into. Negatives are not easy to interpret, and so some kind of intermediate positive image must be created for review. This can be done in the darkroom on photo paper, or on the computer, where you also have the choice of viewing them on-screen or printing just to see a first image.

Contact sheets: A contact sheet is made when a whole roll of 120 (or 35 mm) film is cut into strips and contact printed onto one sheet of 8″ × 10″ or larger photo paper. Contact sheets are commonly used for both black-and-white and color negatives. They can be done by the lab when getting film processed, or in your own darkroom.

Prints: Labs can make machine individual prints from your negatives, usually 5″ × 5″. These almost always cut off some of the Holga's bulging frame, though, and so aren't ideal for seeing all of what you've captured.

Digital: Scan your negatives on a transparency scanner (which lights film from behind), then invert the files to see your images.

Transparency Film: One of the advantages of transparency film is that the final result on the film is a positive image, making for easy review.

Contact Sheet—1st Roll 1967, © Franco Salmoiraghi, Athens, Ohio. Diana camera contact sheet from the early days of Diana. A full Diana roll has 16 frames. See the image created from the four marked frames on page 61.

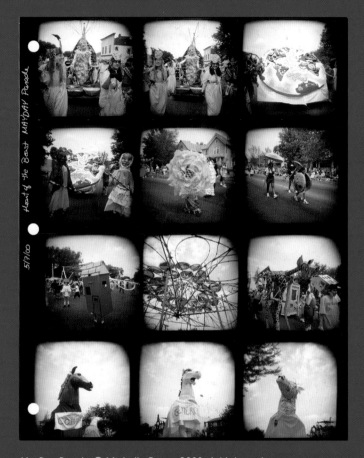

MayDay Parade, © Michelle Bates, 2000. A Holga color-negative contact sheet of the MayDay Parade, put on each year in Minneapolis by In the Heart of the Beast Puppet and Mask Theater. Kodak Portra 400 VC film, contact printed onto Kodak Supra paper in a color darkroom at the Photographic Center Northwest in Seattle.

PRINTING

There are several ways to create final prints to keep or exhibit. Here are the most common options. For simplicity, 5″ × 5″ machine prints from a lab can be your final product. Or you can cut up your contact sheets and have little contact prints to play with. Many labs can make high-quality custom prints from your negatives in a variety of sizes using different types of photo paper. Or, you can go into the black-and-white or color darkroom to do your own printing. And, of course, you can take advantage of the incredible leaps in technology to output digital prints from your scanned film. Now, more detail on each of these ways of proceeding.

DIGITAL INPUT: SCANNING YOUR FILM

To scan negatives and transparencies, you'll need either a dedicated film scanner or a flatbed scanner that has an adapter for transparencies. Film scanners yield higher-quality scans, but at a much higher price. Most of them are designed for 35 mm negatives and slides; ones that can accommodate the larger size 120 film that Holgas and Dianas use are even more expensive. Flatbeds are a much more economical choice for 120 film scanning. In addition, they are able to scan the full width of the film (most film scanners won't), which is an important consideration when shooting with the Holga, which doesn't stay within standard framing. To round out their usefulness, flatbeds can also be used for scanning prints. Consider buying a flatbed scanner for daily use, and, if higher quality scans are called for, rent a film scanner or pay a lab to have scans made.

Once you've scanned your negatives, the resulting files are useful for many things. Digital files allow you to preview images before going into the darkroom, keep track of images, and create files for digital printing or website presentation. Scanned negative files can be retouched or artistically

manipulated, giving the photographer even more options than are available in a wet darkroom. Adobe Photoshop® is a powerful tool for not only adding creative touches to files, but also for saving negatives that would otherwise be unprintable, and fixing specific plastic camera quirks like light leaks. Scans can also be used to output new versions of negatives for darkroom printing, or to create larger digital negatives for contact printing. Contact printing (where the negative is placed directly onto the photo paper, and final prints are the same size as the negative) is used in several classic printing techniques, such as platinum and palladium printing (see Dan Burkholder's book, *Making Digital Negatives for Contact Printing*, Bladed Iris Press, 1999).

All of these tools give the imaginative photographer a variety of places to exploit the technology to further the development of their final image; the possibilities are endless! Scanners, Adobe Photoshop®'s huge selection of filters and plug-ins, printer inks, and paper choices can all be played with as elements in the creation of a final print (or Web) output. Just as a wet darkroom and its paper and chemical options are part of the creative process, so too with the digital darkroom. It's even possible to combine all the technologies by, for example, scanning a black-and-white negative, colorizing it in Adobe Photoshop®, outputting a digital color negative, and printing in a color dark- room. Keep an open mind and experiment!

Final use of your image should be a consideration in how you deal with your negatives. For most commercial and editorial photography, prints have become obsolete, involving extra cost and time; instead, in many venues, negatives can be scanned for direct use. Fine-art photography is where prints still seem to have a place, but even there, a growing proportion of images on gallery walls are output digitally, and, as their longevity increases, digital prints are gaining appeal as collectible fine-art pieces. The world of photography is in transition, and it's up to the individual photographer to decide whether to go wet or go digital for printing, or perhaps combine the two.

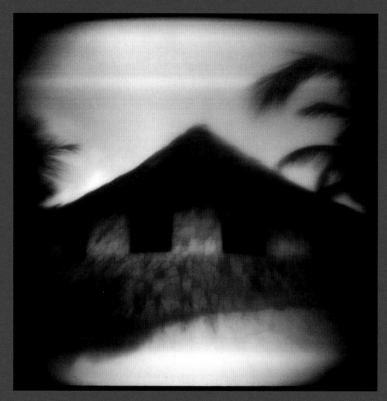

Bungalow, Tulum, Mexico, © Betsy Bell, 2005. Bell shoots with a thin layer of ointment on her Holga lens and a bit of motion blur, then scans her black-and-white images with extra pieces of negative over the scanner's light bar. She chooses the tint of the images based on the feel of the location and image.

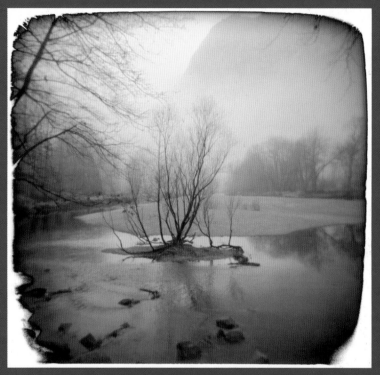

Merced River, Winter, Yosemite Valley, © Ted Orland, 2000. Holga image on T-Max 400 B&W film, scanned, with color added in Adobe Photoshop®. Orland makes the border disappear using Adobe Photoshop®'s blending option.

BLACK AND WHITE

While many people are embracing the seeming ease and daylight of digital printing, fine-art darkroom printing is still very much alive. In fact, this is an excellent time for anyone wanting to set up a darkroom from scratch, because former darkroom printers are fleeing the safelight in droves, and their enlargers and complete darkroom setups can be bought for very low prices, or even obtained free.

A Fortune Teller in Kabul, Afghanistan, © Teru Kuwayama, 2005.
Traditional black-and-white can still be a powerful medium for
image-making and storytelling, as in this Holga image.

Great resources for those without home darkrooms are rental darkroom facilities and schools, which have high-quality black-and-white and color darkrooms available monthly or by the hour. These public facilities are disappearing though, so like many other things, use them or lose them!

Black-and-white darkroom printing can be a rewarding experience of both artistic creation and meditative solo time. It can also be boring, frustrating, messy and smelly. But it's an experience that just can't be compared (for better or worse) to sitting in front of the computer and listening to the printer whiz away. Darkroom prints have a magic that is hard to match digitally. To truly understand the relationship between light, film, and paper, I recommend everyone give it a try.

Black-and-white printing can be done on resin-coated (RC) paper, which doesn't hold up very well, or long-lasting prints can be made on fiber-based (FB) paper. Alternative processes include platinum/palladium, cyanotype, print toning, and hand-coloring, each of which add a different look to your images. Since you're using a plastic camera, why not color outside the lines in the darkroom as well?

Much information is available about basic and advanced techniques: John Hedgecoe's *Workbook of Darkroom Techniques* (Focal Press, 1997) is an excellent introduction, while Ansel Adams' seminal series, *The Camera*, *The Negative*, and *The Print* (Bulfinch, 1995) is for the more technically inclined. Many books also cover alternative processes, and there are thousands of other print and online options for getting information, but taking a class is often the best way to get started.

While monochromatic digital printing capabilities have been improving quickly, getting high-quality black-and-white (as opposed to color) prints from a digital printer is difficult. A few companies offer sets of ink made up of several shades of gray for finely graduated black-and-white prints, but making prints that match those from the darkroom isn't an easy process to master, making it less of an advantage over the darkroom than with color. On the other hand, once you've scanned an image and perfected the file (usually in Adobe Photoshop®), it's possible to output an infinite number of identical prints. Try doing that in the darkroom!

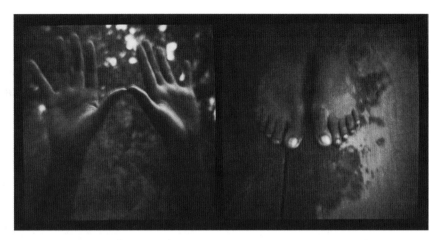

Hands & Feet—Sylvia, © Franco Salmoiraghi, 2002. Diana camera diptych 5″ × 8″ cyanotype print from black-and-white negative.

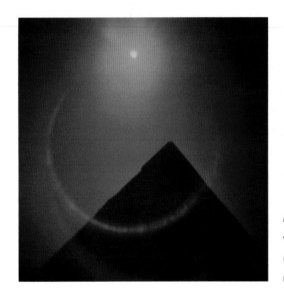

Red Pyramid, © Mary Ann Lynch, 2000. Diana camera image made with Tri-X 400 black-and-white film, and printed on chromogenic (color) paper. A wide variety of hues can be introduced to monochromatic images by using color paper and chemistry.

Darkroom Tips

I'll leave it to the dedicated darkroom printer to find the details elsewhere, but here are a few techniques that are helpful for printing plastic camera negatives.

Multi-contrast paper: Using multigrade (as opposed to graded) paper allows an enormous amount of flexibility in your printing. With this type of paper, you use filter gels, numbered 0-5, in the enlarger to adjust the contrast of your prints. Since Holgas often produce negatives with very high or very low contrast, this is a vital tool for controlling the look of your final prints. I've used the full range of filters in printing my Holga negatives; they need them! You can also use more than one filter in the printing of a single image by using each for only part of the exposure. With this method, you can bring out both low- and high-contrast areas of your images. Combining filters allows you a high level of control, making up for the lack of it in the camera.

Burning: Burning is a very common darkroom method of making specific areas of a print darker. This is done after the main exposure, by turning on the enlarger and using a card with a hole in it, or your hands, to block light from everywhere except the area you're adding exposure to. For a Holga user, burning is an essential tool, especially when trying to repair light leaks.

One specific problem Holga users sometimes encounter is light leaks along the edge of a frame. This may be caused by loose rolling of the film, leaks in the camera, or by two frames running into each other. If you print your images full frame, as I do, and like to have a consistent black border, the lack of a clean edge in this situation can ruin an image. There is a way to restore a border in the darkroom: burning the edge back in without the negative in the enlarger.

To accomplish this, first set up your negative and carrier in the enlarger, and tape the carrier down to the enlarger stage. Then expose your image as normal. Next, open the enlarger to release pressure on the negative carrier, and carefully slide the negative out. Finally, turn on the enlarger, keeping most of the image area covered, except for the missing edge. Experiment with exposure times, and soon you'll have a matching black border to complete your image.

"Filter burning" is another technique used to adjust contrast in part of an image. One way to do this is to, after the main exposure, change the filter in the enlarger, and then burn in the specific part of the print. Alternatively you can hold a piece of a filter under the lens during an exposure, so only the part of the print it covers develops a different contrast.

Dodging: Dodging is another standard darkroom technique that is indispensable to plastic camera shooters. It is the process of blocking light from a portion of the photo paper during the main exposure. You can create special tools for this, or use your hands. Make sure to keep good notes on your dodging and burning, as they are very difficult to repeat accurately when you come back to an image.

Flashing: Holga negatives tend to have contrast issues—too much, too little, or even some of both in the same image. When the highlight areas of a negative are so black it would take the length of an NPR story to get enough light through them to register on photo paper, try flashing. This technique involves giving the paper an overall "flash" of light (without the negative in the enlarger) before or after the exposure through the negative. Flashing is often much easier than burning, and is sometimes the only way to reveal detail in overexposed highlight areas.

Paper developers: Just like film, photographic paper also passes through a series of chemicals to develop and stabilize the image. These consist of a developer, stop bath, fixer, and, sometimes,

fixer remover. The combination of paper and developer also has a profound effect on the resulting look of the image. While the many mainstream developers will work fine for many images, a much finer amount of control is possible with some alternative developer formulations. One, Dr. Beers, gives you several different contrast developer solutions to dunk your print into: you use one or more to fine-tune the overall and midtone contrast of your image. Developers are a powerful tool for perfecting the look of your prints.

COLOR PRINTING

Color-negative printing has never been as popular as black-and-white, but it can also be very rewarding to have control over your color output. I've printed both color-negative (RA-4) and transparency film (onto Ilfochrome, formerly called Cibachrome, paper) at the Photographic Center Northwest in Seattle for years, and I've been amazed at the vibrancy and quality I've achieved with Holga prints, especially compared with what we generally see from mini-labs. It has also been, until recently, the only way for me to make color prints with my extra-special homemade negative carrier, which I would never entrust to a lab!

Color printing can be more difficult than black-and-white, since color balance also figures into the printing variables, and paper must be handled and exposed in complete darkness. Color printing can be done in trays, but it is usually done in tubes, or in machines that process the paper from dry-to-dry after exposure in the darkroom. Some rental facilities offer access to these convenient machines. Printing Ilfochrome is even more difficult, time-consuming and expensive, plus the chemicals are more noxious, but the prints are gorgeous and very long-lasting.

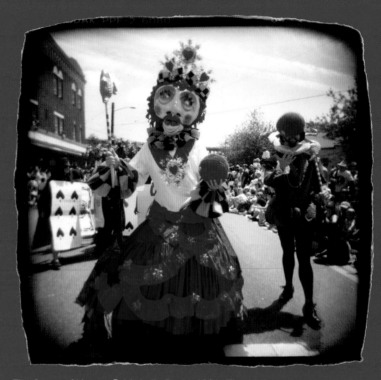

The Queen of Hearts, © Michelle Bates, 1996. This Holga image was made on Kodak PPF color-negative film, and printed in a color darkroom with the author's cardboard negative carrier (then, or course, scanned for this book). The Queen is David Ti, with Terry Frank as her consort, in the Fremont Summer Solstice Parade in Seattle.

FROM PLASTIC TO PIXELS

In recent years, the quality, affordability, and longevity of color digital printing equipment and materials have increased dramatically, making high-quality options readily available. Perhaps the greatest advantage of printing digitally is repeatability. As anyone who has worked in a darkroom knows, making identical prints of an image that requires complex burning and dodging is nearly impossible. In the digital world, the hard work is in getting your file perfected, using the multitude of options you come up against in the digital workflow. But, once your file and printer settings are optimized, it's easy to make as many perfect prints as you like! For all these reasons, digital is not just replacing color darkroom printing, it is also opening up the world of color to many photographers who would never have ventured into a color darkroom.

The rise of digital processes has also changed the workflow of all photography-related industries. Many images these days never even make it to print. Websites are incredible venues for sharing images, and many competitions now accept only digital submissions. Often reproductions in books and magazines are created from files that have never been made into fine-art prints. Online communities allow photographers to meet, share images, and learn from one another.

One downside of all this computer viewing is that the quality of what we're seeing on-screen is much lower quality than what we see when looking at a print, slide or projected image. Computer screens always show images at 72 dpi (dots, or pixels, per inch), which is a very low resolution compared to what the eye is capable of discerning and what we get in physical prints. Another downside to viewing images on a computer is that every computer monitor represents color and light differently, so it's impossible to guarantee that a viewer will see artwork as the artist intended. For this reason, some galleries and competitions still insist on slides or prints for review, but, things are changing rapidly. And, it's now possible to create slides from digital files.

Books on digital image processing and printing are being published almost daily. The technologies improve at lightning speed, requiring continual upgrading of equipment and skills, but also allowing an ever-expanding number of possible results.

So, while a Holga may start off seeming like a simple tool, the options for creating a unique work of art multiply when considering film, processing, and output. Do what you enjoy, what makes your images come to life as you imagined them, and what allows you to keep creating!

PRESENTATION

The presentation of your photography doesn't end with the printing. In fact, many other choices affect the final look of your images. With plastic cameras, an important consideration is the border of your photograph. Holgas (and Dianas to a lesser extent) make negatives with irregular borders. The edges bow outward, resulting in a roundish frame that doesn't stay within the straight edges of standard negative carriers. Some photographers opt to use a stock carrier, and lose some of the frame. Others file out a metal carrier to include the entire area (see Teru Kuwayama's images), and some, like me, achieve this by making their own carriers. In the digital darkroom, you can create any border you like! This is another place to let your creative juices flow.

And finally, don't forget about the matting and framing of your prints. Don't feel constrained by the traditional white overmat. I cut my images out with scissors (it always feels so rebellious!), and mount them onto black photo paper, doing away with white mats altogether. The way you present your images, including the size of the prints, and the frame, is a critical part of how the images are received, and how recognizable they will be as your work.

resources

If you want to see more plastic camera photos, get a toy for yourself, find that rare type of film, learn how to deconstruct your Holga, or learn more about the photographers you've met so far, explore the following list of resources.

PLASTIC CAMERA WEBSITES TO PERUSE

TOYCAMERA.COM

- **www.toycamera.com** ToyCamera.com is the current home of toy camera photographers worldwide. Galleries, articles, group exhibitions, and publications, and an absurdly busy user forum, make you know you're not alone in your love of low-tech cameras. The site has over 100 galleries, hundreds of people on the forum, and sponsored projects including print exchanges, *Lightleaks Magazine*, annual toy camera calendars, World Toy Camera Day (each October), and other publications. Themed contests pop up every once in a while, with forum members voting on the winners.

THE ORIGINAL TOY CAMERA HOME PAGE

- **www.toycamera.org** Created by Jonathan Winters in 1995, this was the first place for plastic camera enthusiasts to flock to. This site isn't current, but it is a snapshot of toy camera history, with extensive galleries of toy images, which never go out of date. It may yet come back to life!

LOMOGRAPHIC SOCIETY

- **www.lomography.com** The Lomo site is a massive conglomeration of cameras and images. You can buy a whole collection of toys here, post your images, have your multiframe images animated, or find out about the latest Lomo shindig.

MORE SITES

- **www.allandetrich.com/diana.htm** Detrich shows off his huge collection of Diana cameras and clones, among other toys.

- **www.digitalsucks.com** This site's motto is "If it ain't plastic . . . it ain't real"

Webrings collect links to sites of particular topics. From the hub, read about each one, or just skip around and be surprised!

- **Toy camera webring: http://f.webring.com/hub?ring=toycamring**

- **Flickr.com** is a photo gallery website that lets images be marked by terms that can be searched. These clusters, pools, sets, and tags allow you to browse thousands of images from whichever camera interests you. Look up any term related to plastic cameras to view images, or post your own and get feedback from other users.

RETAILERS

- B & H Photo (**www.bhphotovideo.com**). A New York institution that carries an enormous selection of everything photographic, including hard-to-find films.

- Film For Classics (**www.filmforclassics.com**). They carry hard-to-find film sizes and offer processing services as well.

- Freestyle Photographic Supplies (**www.freestylephoto.biz**). The U.S. distributor of Holgas has the complete line (including the Holga enlarger and custom camera bags), plus many other plastic options. Freestyle carries a wide selection of film, papers, and other supplies, and specializes in materials for alternative processes. They publish the Holga Manual, available in print, or on the website.

- Holgamods (**www.holgamods.com**). This is the place to get your custom tricked-out Holga, with a selection of modifications by Holga wizard Randy Smith.

- J and C Photo (**www.jandcphoto.com**). This supplier specializes in black-and-white supplies, including very hard-to-find items. They carry rarities like flashbulbs for your Diana flash.

- Lomographic Society (**www.lomography.com**). The home of the Lomo, several multilens cameras, and other accessories.

- Photographer's Formulary (**www.photoformulary.com**). This Montana based company sells a huge selection of chemicals, as ready-made formulations, kits, and individual ingredients for all types of photographic needs. It's heaven for the scientifically-minded photographer.

 BOOKS

Here is a selection of monographs featuring or including plastic camera photos. Many of these titles are out of print and hard to find. Try Abebooks, **www.abe.com**, or **www.amazon.com**; if they're for sale anywhere in the world, they'll be on one of those sites.

ABOUT TOY CAMERAS

- *The Toycam Handbook* (Light Leak Press, Ottawa, Canada, 2005), **www.toycamhandbook.com**. Contains a comprehensive collection of plastic and toy cameras, with images, specs, and fun facts. Also, tips, featured photographers, and lots of images.

TOY CAMERA COLLECTIONS

- *The Diana Show: Pictures Through a Plastic Lens (Untitled 21),* David Featherstone, (The Friends of Photography, Carmel, CA, 1980). The first plastic camera image compilation, from a 1979 exhibition, with a classic introductory essay by Featherstone.

- *Form and Magic: Contemporary Vision with the Plastic Camera* (PhotoCentral, Hayward, CA, 1997). 150 copies were made of the catalog of the exhibition at PhotoCentral, curated by Daniel Miller. A rare treat if you can find one!

- *Holga: The World Through a Plastic Lens* (Lomographic Society International, Vienna, Austria, 2006). With over 300 pages, 500 photographs and 150 photographers, this is a unique collection of work and Holga tips submitted by Lomographers worldwide. Edited by Adam Scott.

- *toycamera,* Group project by (Light Leak Press, Ottawa, Canada, 2005). This black-and-white collection contains images by 26 photographers who frequent **toycamera.com.**

MONOGRAPHS & SOLO EXHIBITION CATALOGS

- *36 Views of Mt. Fuji* (exhibition catalog), K. P. Knoll, with an essay by David Featherstone, G.I.P. (Tokyo, 1997). Knoll's revisitation of the classic woodcut series of Mt. Fuji images, shot with a Holga.

- *Angels At the Arno,* Photographs by Eric Lindbloom, David R. Godine (Boston, MA, 1994). This monograph shows Eric's Diana camera images of Florence, Italy.

- *Beach,* Tim Hixson (Bangalley Press, Avalon Beach, Australia, 1998). A collection of beach photos made with four different plastic cameras.

- *End Time City,* Michael Ackerman (Scalo, Zurich-Berline-New York, 1999). This stunning book of Benares, India, mixes Holga images with a variety of other formats.

- *Faces,* Nancy Burson (Twin Palms Publishers, Santa Fe, NM, 1993). A collection of Diana images of children with a variety of diseases, including progeria, which accelerates the aging process.

- *Fiction,* Michael Ackerman (Kehayoff Verlag, Munich, Germany, 2001). Another collection of Ackerman's work, including some Holga images.

- *Fruit of the Orchard: Environmental Justice in East Texas,* Tammy Cromer-Campbell (University of North Texas Press, Denton, TX, 2006). A documentary project about a town affected by industrial chemical pollution.

- *Imagining Antarctica* (exhibition catalog), Sandy Sorlien (List Gallery, Swarthmore College, 2000). Sorlien's imaginings of what Antarctica would look like, if only she could get there. Holga images interspersed with emails from her brother, who did make it to Antarctica.

- *Iowa,* Nancy Rexroth (Violet Press, 1977). Violet Press and Distributed by Light Impressions of Rochester, NY, 1977. The first monograph done with the Diana. Rexroth explores the mental landscape she calls Iowa.

- *The Last Harvest: Truck Farmers in the Deep South,* Perry Dilbeck (University of Georgia Press, 2006). Dilbeck's documentation of a disappearing way of life in the American south.

- *Mes Vacances avec Holga* Frederic Lebain, (Lomographic Society International, Vienna, Austria, 2002).

- *Nonfiction,* Christopher Anderson (de. MO, Millbrook, NY, 2004). A random assortment of color Holga images all boxed up in a sweet little design.

- *Seeing and Believing: The Art of Nancy Burson,* Nancy Burson (Twin Palms Publishers, Santa Fe, NM, 2002). Includes some of the *Faces* series, some follow-up images of the same children, and a later series, *Healers,* done with the Holga.

MAGAZINES

- *Lightleaks Magazine* (www.lightleaks.org)
 From the toycamera.com community. Full-color collections of images, tips, articles, interviews, and resources, including a full interview with Mr. Lee, inventor of the Holga, in issue #2.

Issue One – October 2005

Lightleaks

A MAGAZINE FOR TOY CAMERA USERS

Special Feature – Unusual

INTRODUCTION by Susan Burnstine
Leon Taylor's TALES FROM THE DARKROOM
FROM THE ARCHIVES by Gordon Stettinius

Ed Wenn's THE PLASTIC GUIDE
THE TOY BOX by Gary Moyer
FEATURED ARTIST – Mike Barnes

toycamera.com

The first issue of *Lightleaks Magazine*.

- *Plastic Fantastic* (www.plasticfantasticonline.com)
This magazine, dedicated to the Art of toy camera photography, had a short lifespan (2005–2006), but check the website for back issues or any updates on publication. Just the images—big, bold, and black-and-white.

- *SHOTS Magazine* (www.shotsmag.com)
A general photography magazine with a high plastic camera content and sense of humor. High quality black-and-white reproductions along with interviews. Edited by Russell Joslin (formerly by Robert Owen and Daniel Price, who founded it in 1986 and published for many years from a tipi in Oregon), P.O. Box 27755, Minneapolis, MN 55427-0755.

📷 PLASTIC CAMERA—RELATED ARTICLES

- **"Alternate View"**: Published by the Maine Photographic Workshops in 1997, this one-time newsletter had a wide variety of articles and images done with low-tech cameras.

- **Camera Arts,** Feb/Mar 1999, pp. 40–46, "Soho Photo Gallery Krappy Kamera Kompetition," by Mary Ann Lynch and Sandra Carrion.

- *Popular Photography,* April 2000, pp. 98–99, 123, "Lomography: Who Says Photography Has to Be Serious?" Bob Lazaroff.

- *Popular Photography,* Jan. 1971, "$1 Toy Teaches Photography," Elizabeth Truxell.

- *Popular Photography,* March 1995, pp. 43–44, "Yo, Shlomo! Lend Me Your Lomo!".

- *SHOTS Magazine:* Dedicated toy camera issues were "Toy Camera Work," issue #12 (1988), "Toy Camera Work II," issue #53 (1996), and "Toy Camera Work 2000," issue #68 (2000).

shots 53

Dad and Dusty Eddie Wexler

toy camera
work II

50644 88598 2

The second of *SHOTS Magazine*'s toy camera issues.

- *SHOTS* #56, "Contemporary Vision with the Plastic Camera," an exhibition of photographs at PhotoCentral Gallery in Hayward, California, April 25–June 5, 1997, p. 44, by Peggy Sue Amison.

Theses letters in SHOTS Magazine track the history of the Diana in the late 1960s:

- **SHOTS #67,** Letter from Arnold Gassan, March 2000.

- **SHOTS #67,** Nancy Rexroth—Response to Arnold Gassan's letter to *SHOTS Magazine*, March 2000.

- *SHOTS# 68,* Letter from William Messer, pp. 44–45, June, 2000.

- *SHOTS #68,* Letter from Timothy Hearsum, p. 47, June, 2000.

Interviews and articles about contributors:

- "Border Crossings: Nancy Rexroth, Fan Ho, Robert Frank," by Mary Ann Lynch, Camera Arts, Dec 2005/Jan 2006, pp. 11–15.

- "Michelle Bates: Art Images from a Toy Camera!," *Silvershotz: The International Journal of Fine Art Photography*, vol. 3, ed. 4, September 2005.

- "My Own Private Iowa," about Nancy Rexroth, by Deborah Garwood, Dec. 12, 2004, **www.offoffoff.com.**

- Pauline St. Denis, "Holga Chic," *American Photo*, v. 11, no. 3 May/June 2000.

- "Perry Dilbeck: Documenting a Vanishing Way of American Life," *The Black and White Enthusiast*, vol. 2, ed. 6, and *Black & White Magazine for Collectors of Fine Art Photography* #6.

- *SHOTS #60,* "Places of Creation: A historical survey of those places where art is born." Photographs and text by Mary Ann Lynch, June 1998.

- *SHOTS #65,* "Nancy Rexroth: From the Gut," interview by Russell Joslin, 1999.

- *SHOTS #68,* "My Travels with Diana," Mark Sink, June 2000.

- *SHOTS #70,* Gordon Stettinius interview by Russell Joslin, Dec. 2000.

- *SHOTS #71,* Anne Arden McDonald interview by Russell Joslin, March 2001.

- *SHOTS #79,* Mark Sink interview by Russell Joslin, March 2003.

Interviews, articles, and projects about others who use plastic cameras:

- Thomas Michael Alleman, "The Los Angeles Project: Sunshine and Noir", *Black & White Magazine for Collectors of Fine Art Photography* Issue #43, May 2006 and **www.allemanphoto.com.**

- Ray Carofano, "Mohave Series", *Black & White Magazine for Collectors of Fine Art Photography*, #20 and **www.carofano.com.**

- Tammy Cromer-Campbell, "Shining a Light into the Dark," by Claire Sykes, *CameraArts*, Feb./March 2001, and "Fruit of the Orchard: Pollution, Environmental Justice, and Social Responsibility," **www.tccphoto.com.**

- Ann Cutting, "Spotlight" *Black & White Magazine for Collectors of Fine Art Photography*, Dec. 2005.

- Heidi Kirkpatrick, "From My Window Seat" and "Iceland" **www.heidikirkpatrick.com.**

- Carl Martin, "Men of Georgia" **www.carlmartinart.com.**

- Annu Palakunnathu Matthew, "Memories of India" **www.annumatthew.com.**

- Vicky Topaz, "Empty Nests—The Dovecots of Northern France" **www.vickitopaz.com.**

- Robert Vizzini , "Cuba: A Land Baked in Time", *B&W Magazine*, #8, and **www.sightphoto.com/sightphoto/story/cuba/cuba.html.**

![camera icon] TOY CAMERA EXHIBITIONS, PRESENT AND PAST

- "About Toy Cameras," Caffe Al Teatro, Prato, Italy, July–August 2001.

- "City TTL," Caffe Al Teatro, Prato, Italy, July 2003.

- "The Camera Obscured," FotoCircle Gallery, Seattle, WA, 1997.

- "Contemporary Vision with the Plastic Camera," PhotoCentral, Hayward, CA, 1997.

- "Holga Works," International Center of Photography bookstore, New York, NY, 1994.

- "Krappy Kamera Competition," Soho Photo Gallery, New York, NY. Soho Photo puts on this annual exhibition, each year juried by a different photographer. **www.krappykamera.com.**

- "Plastic Camera Show," Obscurity Pictures, Australia. Obscurity Pictures hosts this show every year since 2002. **www.obscuritypictures.com.**

- "Plastic Fantastic," E3 Gallery, New York, NY, 1997.

- "The Prospect of Light," The University of Maine Museum of Art, Bangor, ME, 2004. An exhibition of photographic images made with plastic and pinhole cameras, curated by Jonathan Bailey and Wally Mason, **www.jonathan-bailey.com/pages/gal5_prospect.htm.**

- "Reverse Technology," Benham Gallery, Seattle, WA, June, 1997.

- "Toy Stories," Orange County Center for Contemporary Art, Santa Ana, CA, 1998.

📷 CONTRIBUTORS

Michael Ackerman	www.agencevu.com
Jonathan Bailey	www.jonathan-bailey.com
James Balog	www.jamesbalog.com
Michelle Bates	www.michellebates.net
Betsy Bell	www.betsybellphoto.com
Susan Bowen	www.susanbowenphoto.com
Laura Corley Burlton	www.lauraburlton.com
David Burnett	www.davidburnett.com
Nancy Burson	www.nancyburson.com
Perry Dilbeck	www.perrydilbeck.com
Annette Elizabeth Fournet	www.hometown.aol.com/radosti
Jill Enfield	www.jillenfield.com
Megan Green	www.planet-megan.com
Eric Havelock-Bailie	www.erichavelockbailie.com
Wesley Kennedy	
Teru Kuwayama	www.terukuwayama.com
Mary Ann Lynch	www.maryannlynch.com
Anne Arden McDonald	www.AnneArdenMcDonald.com
Daniel Miller	www.danielmillerphoto.com

Ted Orland	www.tedorland.com
Robert Owen	rowen1@mn.rr.com
Becky Ramotowski	www.infinity.my-expressions.com
Nancy Rexroth	rexnex@cinci.rr.com
	www.robertmann.com
Francisco Mata Rosas	www.homepage.mac.com/matiux/PhotoAlbum10.html
Richard Ross	www.richardross.net
Franco Salmoiraghi	francohawaii@yahoo.com
Michael Sherwin	msherwin7@yahoo.com
Mark Sink	www.gallerysink.com
Kurt Smith	www.kurtsmithphotography.com
Sandy Sorlien	www.sandysorlien.com
Pauline St. Denis	www.paulinestdenis.com
Harvey Stein	www.harveysteinphoto.com
Gordon Stettinius	www.eyecaramba.com
;-p r a b u!	floatingcreeper@gmail.com

2000 Turkeys, © Nancy Rexroth, 1973, Albany, Ohio. Taken at the same time as *Turkeys Advance,* in *Iowa.* Courtesy of Robert Mann Gallery.

index

Note: Page numbers in **bold** refers to images.